The Landscape Artist's Drawing Bible

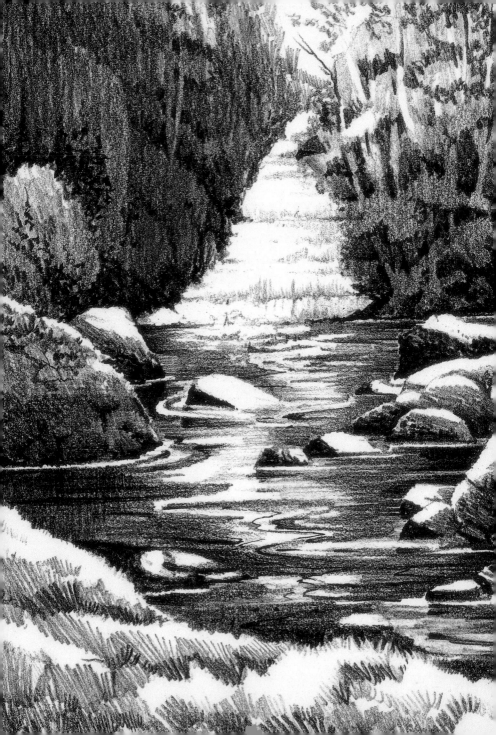

The Landscape Artist's Drawing Bible

edited by
Hazel Harrison

CHARTWELL
BOOKS, INC.

A QUARTO BOOK

Published in 2008 by Chartwell Books, Inc.
A division of Book Sales, Inc.
114 Northfield Avenue
Edison, New Jersey 08837, USA

ISBN-13: 978-0-7858-2361-2
ISBN-10: 0-7858-2361-1

Conceived, designed, and produced by
Quarto Publishing plc
The Old Brewery
6 Blundell Street
London N7 9BH

QUA: LSKB

Project editor & designer: Michelle Pickering
Indexer: Dorothy Frame
Art director: Caroline Guest
Managing art editor: Anna Plucinska

Creative director: Moira Clinch
Publisher: Paul Carslake

Color separation by
Sang Choy International, Singapore
Printed by Midas Printing
International Ltd, China

Contents

Media and marks 6

CHERYL DeCINCES CARTER "Lhassa Calling"

Robert Green Fine Arts
154 Throckmorton Ave, Mill Valley
415 381 8776 www.rgfinearts.com

"SURFIN' ON A SUNDAY AFTERNOON" By Randall Sexton

Knowlton Gallery
Fine Art & Jewelry
115 S. School Street • Lodi
209-368-5123
www.knowltongallery.com

July 2011 night when La Moglia was reluctantly dragged to a San Francisco bar by a girlfriend who wanted to "look for cute boys."

Christina La Moglia

La Moglia had endured "a stream of bad dating" in recent years, and she really just wanted to go home after dinner with Tania, her friend and a fellow salon owner. But she spied her cousin waiting in line outside the bar, so she agreed to go for a little while.

Brown was also outside the bar that night. He remembers seeing an attractive, smiling woman "flying through the air and wrapping herself around" another man. He felt a pang of disappointment, assuming they must be dating, but he overheard enough of their conversa-

Brown sent her text me[s] over the next several da[ys] after she shot down his [in]vitation for a date, he tr[ied to] make a haircut appointm[ent]. She replied that she wa[s] booked but that he shou[ld go] to Tania's salon. Then s[he] called Tania to suggest [that] she or her co-workers m[ight] want to date Brown.

A few days later, La M[oglia] received another text fr[om] Brown thanking her for [the] haircut recommendation[. Mo]ments later, her cell pho[ne] rang. It was Tania beggi[ng her] to give Brown a chance. [Final]ly, she agreed and sched[uled] drinks with him and a fe[w]

Techniques and tutorials 44

Gallery 134

Photo directory 156

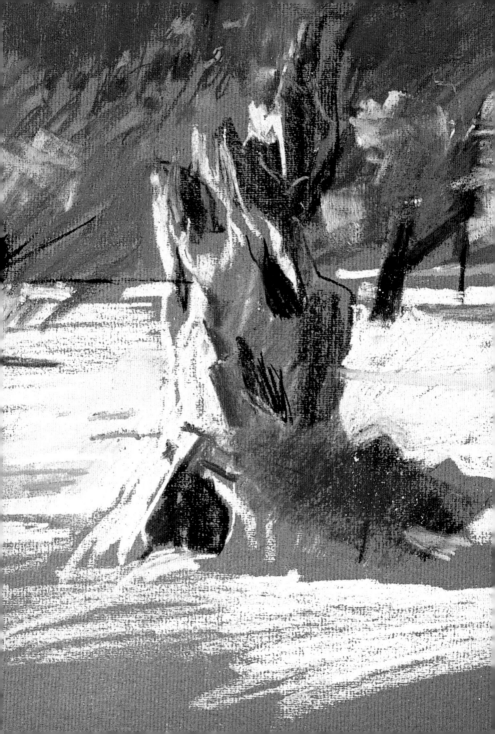

1
Media
and marks

Drawing media and mark-making
techniques for landscapes

Pencils and graphite

A wooden pencil consists of a graphite strip, commonly called the lead, sealed in a wooden case. It is the perfect flexible medium, creating a wide variety of expressive marks. Pencils are made in a range of grades, from very hard to very soft. H–9H indicates increasingly hard leads, while B–9B indicates increasing degrees of softness and blackness. The hardest pencils make fine, pale gray lines; the softest produce thick black ones. HB pencils are medium grade. There are also pencils graded F, which have a fine point. As a general guide, you will need at least an HB, a 2B, and a 4B. Graded leads are also made for some mechanical pencils.

A graphite stick looks like a thick pencil, but without the covering of wood. These are also graded, with 2B being a useful average. They are good for large, tonal drawings, because you can cover large areas rapidly by using the side of the stick.

ARTIST'S TIP

When working on the final stages of a graphite drawing, lay a clean piece of paper over completed areas so that you can rest your hand on it and avoid smudges.

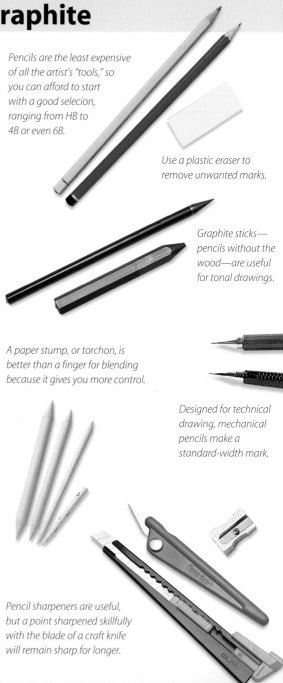

Pencils are the least expensive of all the artist's "tools," so you can afford to start with a good selecion, ranging from HB to 4B or even 6B.

Use a plastic eraser to remove unwanted marks.

Graphite sticks—pencils without the wood—are useful for tonal drawings.

A paper stump, or torchon, is better than a finger for blending because it gives you more control.

Designed for technical drawing, mechanical pencils make a standard-width mark.

Pencil sharpeners are useful, but a point sharpened skillfully with the blade of a craft knife will remain sharp for longer.

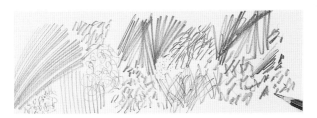

Linear strokes

Pencils can be used to create a wide range of linear effects, from long and short strokes to dots, dashes, and scribble marks, all of which can be used to build tone and texture. Note the difference between the lines made with a B, 2B, and 6B pencil (left to right).

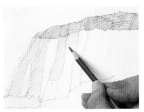

Hatching

Hatch or crosshatch lines to build up areas of varying tone and density.

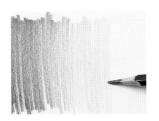

Shading

Angle the pencil so that it is almost parallel with the paper when shading. Use a soft pencil (left) or a graphite stick for faster, broader marks (right). The heavier the pressure, the darker the tone.

Erasing

Use an eraser to lift out highlights, adjust tones, or correct mistakes.

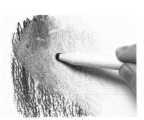

Blending

Tones can be varied and lightened by blending different weights of pencil or graphite with a finger, paper stump, or soft eraser.

ARTIST'S TIP

When the end of an eraser becomes rounded with wear, use a craft knife to trim a sharp edge for precise work.

Form and texture—trees

Pencil and graphite can convey texture with subtlety. When drawing a tree, note that the texture of the trunk is much more pronounced than on the branches.

To help make your branches look three-dimensional, you may find it helpful to view them as a series of connected cylinders.

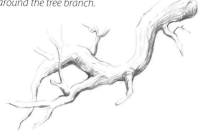

Note how the bark gets denser at the edges as it wraps itself around the tree branch.

ARTIST'S TIP

When you have finished a drawing in soft grades of pencil or graphite, fix it lightly (see page 14) or it will smudge, particularly in a sketchbook that will be carried about frequently.

Lifting out—clouds

Use a combination of layering, blending, and erasing to create a sky with clouds.

1 Crosshatch the sky, then blend it with a chamois leather wrapped around your finger. Repeat to create a smooth finish.

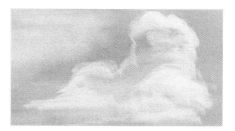

2 Use a plastic eraser to lift out the shapes of the clouds. For light, wispy clouds, simply drag a kneadable eraser across the surface.

3 Add darker layers to the tops of the clouds, then blend them in using a paper stump.

Tonal range

Using a variety of marks will give life to your pencil drawings. You can use a single pencil to achieve a wide range of tones simply by altering the pressure. However, there is a danger of making the light tones darker than they should be, and vice versa, so using different pencil grades may be a better option.

The side of a pencil has been used to shade the sky, which was then softened with an eraser. This produces a surprising variety of tones, and contrasts with the marks used for the foliage.

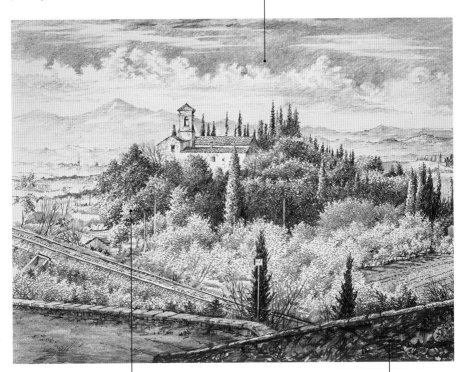

Use a variety of small strokes to create the texture of the foliage.

The shadowed foreground is built up from broad, dense strokes, thus highlighting the lighter elements in the drawing.

Charcoal

Charcoal, a carbonized form of wood, is a delightful medium to use. Willow charcoal is made from the peeled twigs of the willow tree and is usually sold in boxed bundles, graded fine, medium, and thick for width, and soft, medium, and hard for consistency. Charcoal pencils are made from compressed charcoal—this is less messy to handle than willow charcoal, but less easy to dust off. Carbon pencils use a mixture of charcoal and graphite, and are made in a range from B to 6B.

You will need to spray charcoal drawings with fixative to prevent them from smudging (see page 14). This is produced in aerosol cans, and hairspray can also be used.

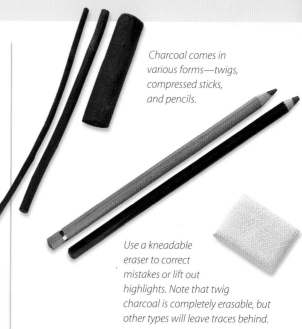

Charcoal comes in various forms—twigs, compressed sticks, and pencils.

Use a kneadable eraser to correct mistakes or lift out highlights. Note that twig charcoal is completely erasable, but other types will leave traces behind.

ARTIST'S TIP

Charcoal pencils produce a lovely sensitive line as long as they are kept to a very sharp point. Sharpen them by rubbing them on a piece of sandpaper, because using a knife can break the point. You can sharpen thick charcoal sticks and compressed charcoal in the same way.

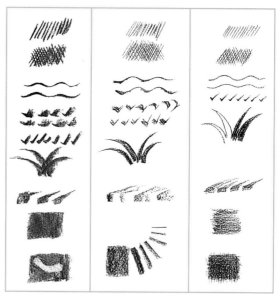

Willow charcoal Compressed charcoal Charcoal pencil

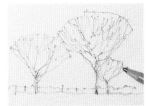
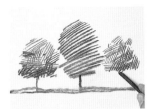

Linear strokes

Stick charcoal produces expressive, linear strokes (left). Vary the thickness of the stroke by changing the angle of the stick. Carbon pencil gives a rich black line with very little pressure (right). Used on damp paper, it produces an even denser, velvety black line.

Hatching

Thin charcoal is a useful medium to use for building up a web of hatched or crosshatched lines or marks.

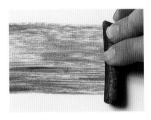

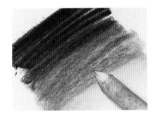

Shading

Use a charcoal stick on its side to create shading with wonderful textures.

Blending

You can brush off excess charcoal or blend charcoal marks using a finger, soft brush (left), paper stump (right), finger, or cloth.

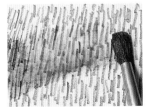

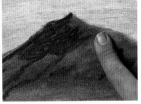

Wet brushing

A line made by a charcoal or carbon pencil will spread and soften when washed over, making some wonderful grays.

Lifting out

Create highlights in an area of tone—or correct mistakes—by lifting out the charcoal with a kneadable eraser; pull it into a point for small details. This can produce a variety of effects, from sharp lines to texture and highlights.

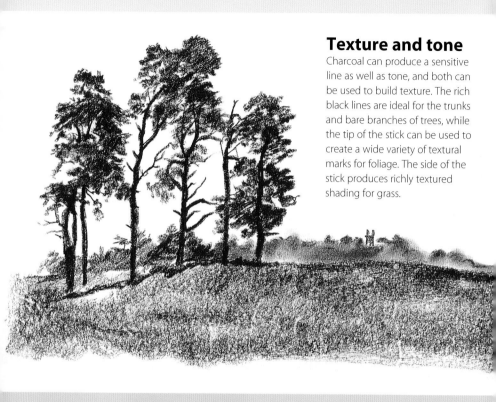

Texture and tone

Charcoal can produce a sensitive line as well as tone, and both can be used to build texture. The rich black lines are ideal for the trunks and bare branches of trees, while the tip of the stick can be used to create a wide variety of textural marks for foliage. The side of the stick produces richly textured shading for grass.

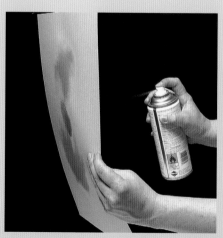

USING FIXATIVE

Fixative is a mixture of resin and spirit solution that is sprayed over drawings made in soft media, such as charcoal and soft pastels. It leaves a matte layer of resin that coats and holds any loose pigment dust in place. Fixative is available in aerosol cans, and should always be sprayed away from the face and clothing. Avoid breathing it by spraying outdoors, or by leaving the room until the air clears. Fixative is widely available, but quite expensive, and some artists use hair spray as a cheaper alternative.

Light and dark

Compressed charcoal pencils are also available mixed with chalk to make shades of gray and even white. To make your own pale shades, draw with white chalk first and then work black compressed charcoal into it. Do this gradually, because it is easy to over-darken. Charcoal is ideal for studying perspective, because the marks can easily be removed or altered.

White highlights in the distance accentuate the dark passage that leads to them.

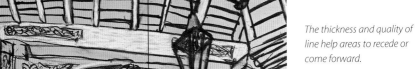

The thickness and quality of line help areas to recede or come forward.

Use the sharpened edge or point of an eraser in charcoal-filled areas to retrieve lost highlights and introduce new ones to shadowed areas.

Conté

Conté crayons are square-sectioned, slightly waxy sticks made from pigment and clay. They have a density and crispness of mark similar to charcoal pencils. Conté is also available in pencil form, sometimes called carré pencils. These are easier to control and can produce both tone and sharp line. Conté crayons and pencils are normally available in black, white, bistre (dark brown), sepia (red-brown), and sanguine (terracotta). The limited color choice makes conté an ideal progression from monochrome to color.

Conté is soft enough to smudge, so spray completed drawings with fixative (see page 14), or cover each drawing with tissue or tracing paper if you are storing them in a drawer. If you are working in a sketchbook, it may help to begin at the back and work forward, because the pages are less likely to rub over each other and smudge.

ARTIST'S TIP
Work in conté crayon from the outset rather than starting with a pencil sketch, because graphite and conté are both slightly greasy and don't mix.

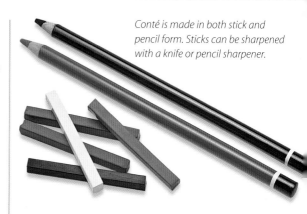

Conté is made in both stick and pencil form. Sticks can be sharpened with a knife or pencil sharpener.

This townscape was drawn in sanguine conté with white conté highlights. Large areas of tone were blended with a cloth.

Linear strokes

Used on its edge, a conté stick will make a variety of different textural marks; however, a conté pencil will make a finer line.

Hatching

Like a graphite pencil, a conté pencil can be used to hatch and crosshatch in order to build up tones and textures.

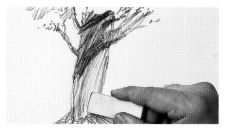

Shading

Use a conté stick on its side to produce a block of solid color.

Erasing

Use a kneadable eraser to make corrections, produce tone or texture, or lift out highlights.

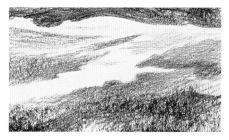

Atmospheric effects—skies

Vary your strokes to produce different effects. Gentle criss-crossing curves create a sky with plenty of movement (left), while broad, sweeping side strokes evoke a calm, still day (right).

Dry pastels

Pastels are colored sticks made from powdered pigment mixed with just enough gum or resin to bind them together. There are two main types: soft, which are usually round-sectioned, and hard, which are usually square-sectioned. Some are cased in paper to protect your fingers from the color, which powders and rubs off easily. There are also pastel pencils, which are cleaner to use but lack the versatility of "real" pastels.

Pastels can be bought singly, and are also available in boxes of assorted colors and in special subject-related sets, including landscape colors. Sandpaper or glasspaper can be used to sharpen pastels for detailed work. Pastels need a textured surface to hold the color, so it is best to use pastel paper made for the job. Pastels have to be fixed to prevent smudging (see page 14), but avoid overzealous spraying because it can darken the colors.

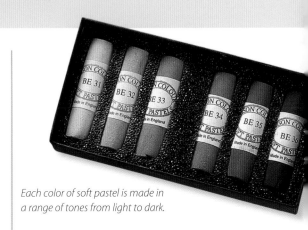

Each color of soft pastel is made in a range of tones from light to dark.

Hard pastels contain a higher proportion of additives, making them less prone to breaking and easier to handle than soft pastels.

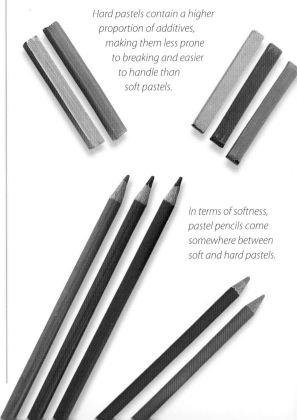

In terms of softness, pastel pencils come somewhere between soft and hard pastels.

ARTIST'S TIP

Graphite is not ideal for an under-drawing, because it is slightly greasy and tends to repel the pastel color laid on top. Pastel pencils are a better choice.

Linear strokes
Use the end or edge of the pastel stick to create lines, strokes, dashes, and dots.

Hatching
Crossing one set of hatched lines with another increases the density of color and tone.

Shading
Used on its side, pastel produces a broad area of solid color. Changing the angle is useful when sketching moving water.

Blending
The finger is an ideal tool for blending and can be used to vary the density of tone, such as for aerial perspective (left). Colors can be built up quickly by blending crosshatched lines of different colors (right); use a finger, dry brush, cloth, or paper stump.

Erasing
Use a kneadable eraser to lift out highlights and correct errors. The more pigment on the paper, the less easy this is.

Layering colors
Mix colors by layering them. Very different effects can be achieved, from a loose overlay (left) to a denser mixture of strokes (right).

Wet brushing
Brush pastel with water to spread or mix colors.

Tone and line—trees

Pastel is an amazingly versatile medium. A pastel stick can be used on its side to create broad strokes, or the tip can be used to make thinner, crisper marks. Pastel pencils are ideal for finer linework. The powdery quality of pastel makes it possible to blend several colors together.

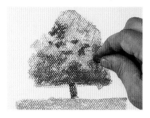

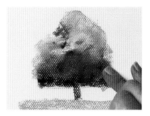

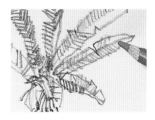

1 Use the side of a pastel stick to draw the shape of the tree as an area of tone, then add smaller, darker marks.

2 Use a finger, brush, cloth, or paper stump to blend and blur the edges to create a tree with depth and texture.

3 To draw a tree with finer linework, use a pastel pencil. You can use pastel pencils to work detail into a drawing made with soft or hard pastels.

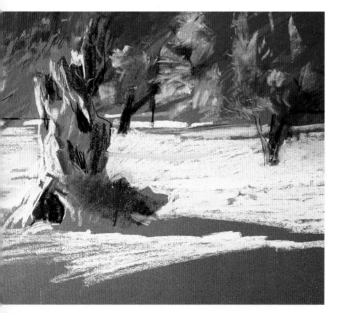

4 Smudge the lines with a finger or paper stump to soften your drawing and blend the colors of the tree.

This drawing of an olive grove on blue pastel paper exploits the linear quality of pastel to create areas of exciting color.

Mixing colors—aerial perspective

Utilize the different methods of mixing pastel colors to give the effect of space and recession. The sky and distant hills have been well-blended in this drawing, the colors in the middleground only partially blended, and the colors of the foreground foliage created by layering strokes of different colors with no blending.

The thorough blending of the colors in the sky and distant hills pushes them into the distance.

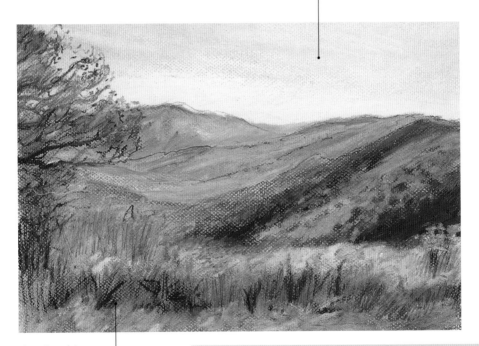

The colors of the foreground foliage are mixed optically rather than blended together.

ARTIST'S TIP

Pastel is a fragile medium, and complicated color mixtures can look dull and muddy. Expand your range of stick and pencil colors so that you can keep blends simple. Don't overfill the grain of the paper in the early stages, or it will be difficult to lay more colors on top.

Oil pastels and paint sticks

Oil pastels are sticks of color that are bound with oil rather than gum, which makes them soft and greasy. They vary from stiff to slippery; the softest mix well, and the stiffest are good for drawing details. They can also be worked into with turpentine or mineral spirit. The fat content in oil pastels makes their colors rich, and they can be opaque, semitransparent, or transparent. Handled well, they can produce effects similar to oil paint, and because they do not powder, they are easier to control than dry pastels. Oil pastels do not dry, so avoid rubbing them, or use special oil-pastel fixative.

Paint sticks, also known as oil bars, are oil paint in stick form and can be mixed with tube paints for oil sketching. They contain dryers and need no fixative, but will smudge easily until dry.

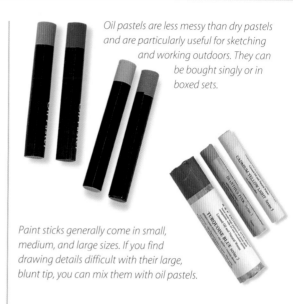

Oil pastels are less messy than dry pastels and are particularly useful for sketching and working outdoors. They can be bought singly or in boxed sets.

Paint sticks generally come in small, medium, and large sizes. If you find drawing details difficult with their large, blunt tip, you can mix them with oil pastels.

Sweeping strokes of blue oil pastel blended with spirit form a dramatic sea and sky. Broken dabs of white suggest the foam of breaking waves, while dynamic strokes of gray scratched with diagonal lines enhance the sense of movement.

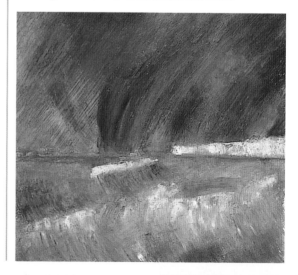

ARTIST'S TIP
Layers of color can be built up with oil pastel in the same way as for dry pastels, but because of their greasy texture, they tend to clog the grain of the paper more quickly, so make sure you work lightly at the outset.

Linear strokes
Use the tip of the stick to make fine linear strokes and textural marks.

Shading
Remove the wrapping so that you can use the side of the stick to shade broad areas of tone.

Sgraffito
Oil pastels are perfect for sgraffito techniques. Here, a craft knife is being used to scratch out blades of grass.

Layering colors
Build up colors in layers like traditional oil paint.

Scumbling
Apply colors over each other in light veils, so that each color only partially covers the one below.

Blending sticks
Colorless paint sticks can be rubbed over colors to smooth them out; they can be used with oil pastels or paint sticks.

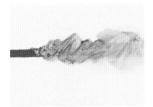

Wet brushing
Use a brush dipped in turpentine or mineral spirit to soften and spread lines of oil pastel (left) or blend colors together (right). You can also use a cloth dipped in spirit to erase errors.

Dry brushing
Paint sticks can be blended without solvent using a stiff bristle brush.

Colored pencils

Colored pencils are thin sticks of color encased in wood. Some are relatively hard and can be sharpened so that they make very incisive lines. Others are softer and more like pastels to use, except that they are much more manageable. Like graphite pencils, colored pencils are cheap, portable, and convenient, and have the same lively, linear qualities. As with pastels, colors can be mixed by laying one over another.

There are also water-soluble colored pencils, sometimes called watercolor or aquarelle pencils, that can be used wet or dry. If you draw on the paper with a dry pencil, you can then wet the area of color with a soft brush dipped in clean water and spread it just like watercolor. You can also dip the pencils in water and use them directly on the paper.

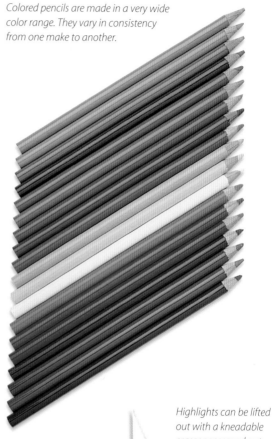

Colored pencils are made in a very wide color range. They vary in consistency from one make to another.

Highlights can be lifted out with a kneadable eraser or scraped out with a craft knife and boosted with white.

ARTIST'S TIP

Different color mixtures can be achieved by layering the same group of colors but in different sequences, so experiment to discover the best order for a particular shade. Note each contributing color, and the order used, beside the final mixture on a shade card. Your color mixing will improve rapidly when you have examined all the possible combinations.

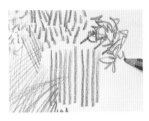

Linear strokes

Colored pencils can create
fluid lines and textural marks
of varying thicknesses.

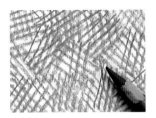

Hatching

Build up density, tone,
and texture by hatching
and crosshatching lines.

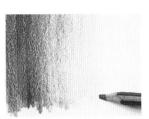

Shading

Angle the pencil to shade in
areas of tone. Lighter pressure
will result in lighter tone.

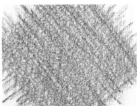
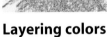

Layering colors

From a distance, colors that are closely hatched will appear as a
solid blend (left). More solid color mixtures can be created by
shading one color on top of another (right).

Blending

Blend soft pencil colors
with a paper stump, cloth, or
finger. The colors of harder
pencils spread less easily.

Burnishing

Shade over existing colors
with a white pencil to produce
a glazed surface (or use a
paper stump or plastic eraser).

Wet brushing

Washing over two layers of water-soluble color will create a wash
of a new color (left). Very strong textures can be produced by
layering a water-soluble color over ordinary colored pencil strokes
and then washing over with water—ideal for grass (right).

Linear color effects

Flat tonal areas tend to project a smooth surface appearance that lacks texture. Using line as a vehicle for your colors, or combining line and tone, allows you to convey movement as well as color. Colors built up from lines either over or alongside one another will add shape, direction, and texture to the form. Using dots and dashes of color achieves probably the greatest complexity and texture possible, but is very laborious. Use it for small drawings; if the work is large, the technique will not achieve its aim, because the color and texture will be lost rather than heightened.

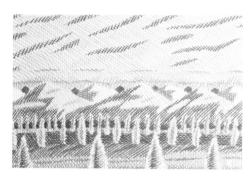

The dense build-up of lines in the middleground forms a solid base against which the snowy peaks and white edges of the cypress trees are highlighted.

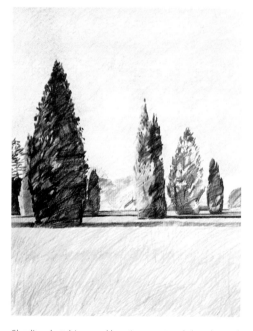

ARTIST'S TIP
To create a sharp edge, lay a ruler on the paper and apply strokes of colored pencil up to the ruler, working along the required length.

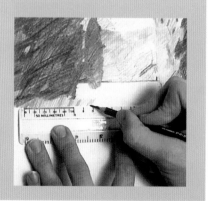

Shading, hatching, and layering create subtle color and tone in this garden scene. Note how the closely applied lines of the sky recede, while the loosely worked web of lines for the grass spring forward in lively motion.

Colored-pencil washes

Washes of water-soluble pencils are seldom as intense as ordinary watercolor washes, but they do allow you to create broad areas of color more quickly than you can with dry pencils, where you have to use the relatively slow hatching and layering methods. If working this way, remember to stretch the paper first (see page 37). To make alterations, you can wash out the unwanted parts. Pale colors are ideal for making preliminary sketches in wash drawings, because they dissolve in subsequent washes, instead of showing through transparent colors in the way that graphite does.

The sky and hills have been washed over just enough to make the color run slightly, and allowed to dry with a hard edge.

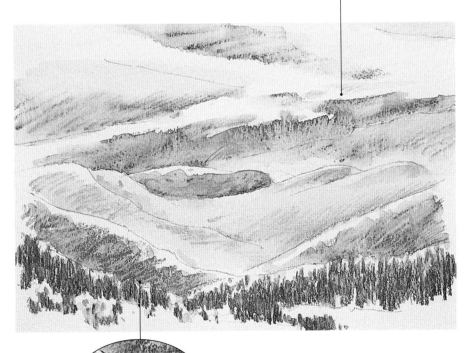

Dry pencil marks bring the foreground forward in space, and echo the jagged edges formed where the wet washes behind have spread and dried.

Ballpoint and technical pens

There is a huge variety of drawing pens available. Ballpoint and technical pens produce lines of uniform width, but can yield lively results if you vary the marks you make. Both make very useful drawing tools, particularly for outdoor work. Ballpoints are only available in a limited nib size, but they can be found in an ever-growing range of colors. Rollerball pens are a type of ballpoint, but tend to be slightly "wetter," and deliver more ink.

In technical drawing, evenness of line is essential, and the stylo-tip pen was evolved to meet this requirement. These pens have tubular nibs that are available in a wide range of widths. You can buy disposable technical pens that are perfect when traveling, or refillable pens with interchangeable nib units so that you can use several nib sizes with one barrel.

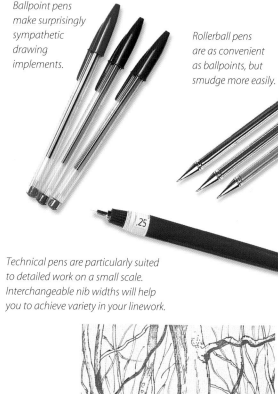

Ballpoint pens make surprisingly sympathetic drawing implements.

Rollerball pens are as convenient as ballpoints, but smudge more easily.

Technical pens are particularly suited to detailed work on a small scale. Interchangeable nib widths will help you to achieve variety in your linework.

Linear marks have been combined with stippling to build up the texture and tone of the tree and foliage.

ARTIST'S TIP

Ballpoint and technical pens are relatively clean to use, but can smudge if the marks are touched before the ink has dried properly. It is wise to use a spare sheet of paper to protect completed areas as you work.

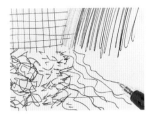

Linear strokes

Although ballpoint and technical pens produce lines of uniform width, varying your marks will produce lively and spontaneous results.

Varied lines

Linear strokes made using different nib widths produce varied depths of tone (left). You can also adjust the pen pressure to achieve varied linework, holding the pen loosely and allowing it to skip across the paper surface (right).

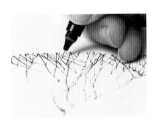

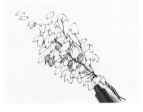

Descriptive marks

Build up a web of varied lines following different directions. This is ideal for drawing the skeletal branches and trunks of trees in winter.

Detail work

Pens are ideal for detailed linework, such as leaves.

Stippling

Try creating tone with a series of dots instead of lines. Different nibs widths—fine (left) and thick (right)—can produce remarkably varied results.

ARTIST'S TIP

Vary your marks to suit the subject. For example, use evenly spaced hatching to add tone to a building, and random marks for organic subjects like leaves.

Fiber-tip pens and markers

Fiber-tip pens and markers are produced in a vast range of types, a large selection of vivid, clear colors, and an almost daunting range of point thicknesses, from extremely fine to thick, wedge-shaped tips. They produce a dependable, flowing, and consistent line, and with their soft tips, they are almost as sensitive as the tip of a brush. They are available in both water-soluble and spirit-based varieties. Use water-soluble pens if you want to create line-and-wash effects. The spirit-based colors tend to spread—"bleeding" beyond the shape drawn by the nib. Another problem with the colors is that they may fade when exposed to light, although several manufacturers now produce ranges of permanent inks.

The range of fiber-tip pens is bewilderingly large. Try them out before buying, and make sure they are colorfast.

Markers are made with both fine tips and broad, wedge-shaped ones, the latter being useful for shading large areas.

ARTIST'S TIP

Take care when using fiber-tips and markers in sketchbooks because the colors may bleed right through the paper and ruin other drawings. There are some marker pads made with special paper that largely controls the problems of color bleeding.

Brush pens are a type of marker with a flexible, paintbrush-shaped nib. They are good for creating flowing, expressive marks.

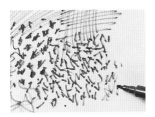

Linear strokes

A wide range of fiber-tip pens and markers is available that can produce a variety of lines and marks. Experiment with different sizes and shapes of nib.

Shading

Use a wide-tipped marker to shade blocks of color.

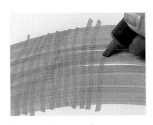

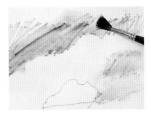

Layering colors

Marker ink is transparent, so you can mix colors by layering one over another to produce subtle or bold gradations of color and tone. It is usually best to layer from light to dark.

Wet brushing

When using water-soluble pens, you can make interesting effects by brushing with water.

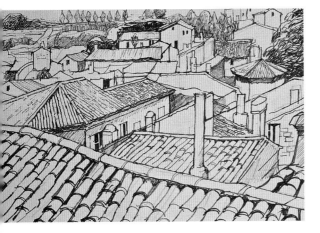

Fiber-tip pens lose their sharpness with use, so save old pens for background areas where less clarity of line is desirable. In this drawing on pink pastel paper, the artist has used a variety of textural marks to build form and tone.

Traditional pen and ink

Pen and ink is a delightful and flexible medium that has been popular with artists for centuries. A great many types of pen are available today: dip pens that can be used with a selection of nibs; art or fountain pens that also have interchangeable nibs; and the more traditional quill, reed, and bamboo pens. They have different characteristics, so experiment on scrap paper first, and then choose the type that suits your purpose best.

There are many different drawing inks, but the two main categories are waterproof and water-soluble. Waterproof inks dry to a glossy film, while water-soluble inks dry to a matte finish, sinking into the paper more than other inks. They can be diluted with water to give a range of tones. See pages 34–37 for more information on using inks.

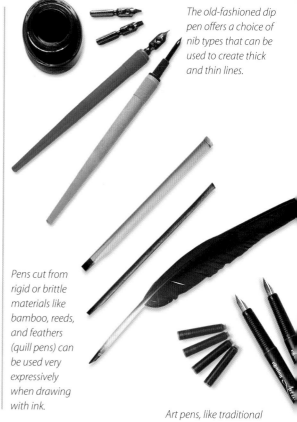

The old-fashioned dip pen offers a choice of nib types that can be used to create thick and thin lines.

Pens cut from rigid or brittle materials like bamboo, reeds, and feathers (quill pens) can be used very expressively when drawing with ink.

Art pens, like traditional fountain pens, hold a cartridge that delivers a steady flow of ink. They offer a choice of nib types.

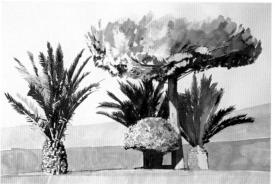

The dip pen is capable of a variety of marks that are perfect for drawing the graceful shapes of the fronds of palm trees. Use the broad area of the nib for wide marks, the side for narrow ones, and the back for fine dots and lines.

Dip pen
The dip pen's capacity to accept a wide range of nibs makes it extremely versatile.

Quill pen
The natural feather quill makes a range of unique marks.

Bamboo pen
A bamboo pen runs out of ink quickly, and enables a range of marks from dark to light.

Reed pen
Reed pens are similar to bamboo pens, but are slightly thinner.

Art pen
These pens are quick and clean to use, making them good sketching tools.

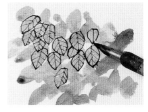

Line over wash
Used here over a dry wash, the dip pen and ink create crisp spring leaves.

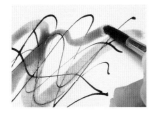

Wet brushing
Water-soluble ink brushed with water produces delightfully expressive flowing lines (left). If water-resistant ink is used, you can apply tonal washes to linework (right).

ARTIST'S TIP
Use gouache paint to white-out unwanted marks, or scrape them off the paper carefully using a sharp knife; both these techniques affect the surface, so use them only at the end of your work.

Brush and wash drawing

Drawing with a brush is an excellent way of recording impressions quickly. Brushes that point well can be used to make any mark, from a fine line to a sweep of wash. Brushes with no spring, or that do not come to a point, will not draw a controlled line. Chinese brushes are useful for delicate work where you need a very fine point.

Washes can be made by diluting any water-based paint or ink. Translucent watercolor washes are ideal for landscapes. The most common type of drawing ink nowadays is acrylic ink, but you can also use any of the inks sold for writing pens. Most drawing and writing inks can be diluted with water and used for washes. Waterproof inks, such as India inks, contain shellac, which fixes them when dry. Acrylic inks also become waterproof when dry. Chinese ink comes in the form of sticks and is made into a liquid by grinding it against an ink stone with water.

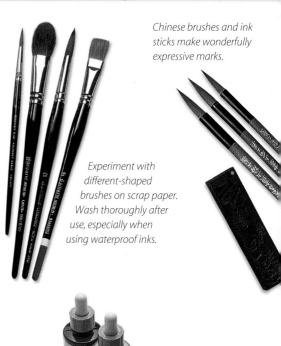

Chinese brushes and ink sticks make wonderfully expressive marks.

Experiment with different-shaped brushes on scrap paper. Wash thoroughly after use, especially when using waterproof inks.

Liquid acrylic inks are just one of the many types that can be used for brush and wash drawing.

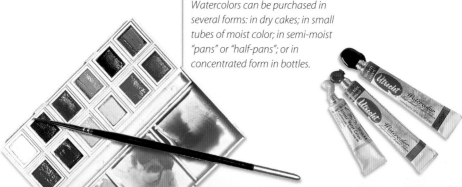

Watercolors can be purchased in several forms: in dry cakes; in small tubes of moist color; in semi-moist "pans" or "half-pans"; or in concentrated form in bottles.

Linear strokes

Marks made with a Chinese brush and ink. Experiment with different types of brush.

Blot drawing

Blots of ink dropped onto wet paper form interesting patterns for creating drawings.

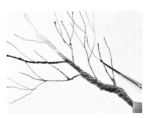

Fine linework

Use a fine, long-script liner brush for the branches of trees and twigs.

Tone

Vary the angle of the brush or the pressure on the paper to alter the thickness of the line (left). You can also dilute the ink with water to create tone (right).

Dry brush

Remove excess paint from the brush, then drag it over the paper surface to draw blades of grass. Stiffer bristle brushes are best for this technique. To create highlights, you could scratch out a few lines with the tip of a craft knife (see sgraffito, page 23).

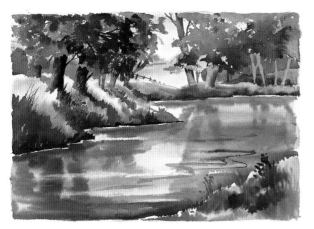

This monochrome wash drawing sparkles with reflected light. Horizontal sweeps of color have been lifted out with a tissue to define the surface of the water.

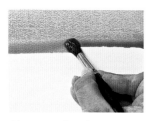

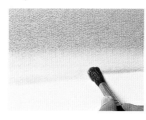

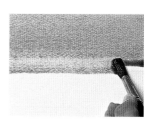

Flat wash

A flat wash needs to be applied at a slight angle. Load a large wash brush with paint and, starting at the top, make a steady horizontal stroke across the paper. The next stroke will need to overlap the first slightly.

Graded wash

Perfect for clear blue skies, a graded wash is a variation on the flat wash. However, each time you make a horizontal stroke, add more water to the mixture, making it slightly lighter (or add more paint to make it darker).

Two-color wash

This wash is similar to the graded wash, but you need to change color part of the way through the process, using a clean brush. This effect is perfect for sunsets.

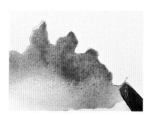

Defined edge

To create defined edges, wet the paper only to the required limit of the color.

Wet-in-wet

Apply wet paint over or into an area that is already wet with paint. Depending on how wet the base layer is, the colors will blend together.

Lifting out

Lift out areas of wet paint with a tissue. This can be used as an erasing technique, and also for special effects such as fluffy clouds.

ARTIST'S TIP

Mix plenty of wash before drawing; having too much is preferable to running out in the middle of a large area.

Collapsible waterpots for mixing, diluting, and cleaning are perfect for location work.

Line and wash

Don't restrict yourself to the traditional pen and wash. Other drawing media can be combined with washes to produce equally exciting results.

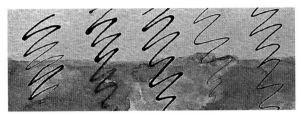

Various pens on wash, with another wash laid over them

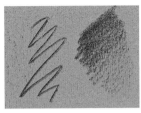

Colored pencil on wash

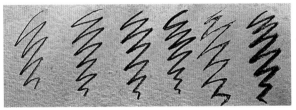

Different grades of graphite pencil on wash

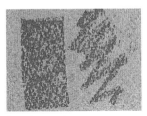

Pastel on wash

STRETCHING PAPER

Most paper will swell and buckle if it is wet. When working with any wet medium, such as ink or watercolor washes, stretch the paper to keep it flat.

1 Soak the paper and lay it on a board.

2 Cut a length of gumstrip for each edge and moisten it with a damp sponge; don't wet it too much or it may tear.

3 Stick gumstrip around the edges of the paper. Allow the paper to dry naturally. When the work is complete, cut through the tape with a knife.

Resists

Masking fluid is a rubber latex solution that is applied with a brush to preserve areas of a drawing from applied color. The masked areas can be colored after the fluid has been removed. You can also apply the masking after you have laid one wash of color and then paint on a second darker hue. This process can be repeated several times.

Oil and wax do not mix with water, so they can be used as partial resists. If you scribble lightly on paper with a candle and then lay on washes of watercolor or colored inks, the color will slide off the waxed areas. Wax crayons (the kind sold for children) or paint sticks can be used for this. Artist's turpentine also acts as a partial resist.

Oil pastel will also resist fluid color, and drawings can be built up in layers. You can alternate applying ink or watercolor over oil pastel and vice versa, until you are satisfied with the result. When working oil pastel over an ink layer, you might also exploit the sgraffito method (see page 23). For example, in a drawing of trees, you could begin with a yellow ink layer, overlay it with darker oil pastel colors, and then scratch back to the yellow for highlights and touches of detail.

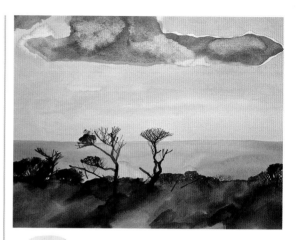

The trees were painted with masking fluid before the yellow and blue washes were applied, then colored with black.

In this oil pastel and ink drawing, the lighter pastel colors have resisted the ink more than the darker ones.

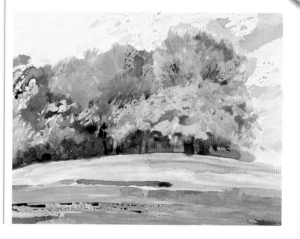

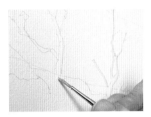
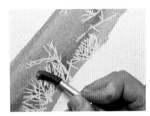
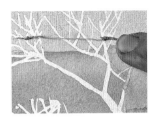

Masking fluid—trees

Using a fine brush, draw the trees with masking fluid (left). Allow to dry, then apply the wash to the background area (center). The masking fluid will repel the wash. Allow the wash to dry, then gently rub off the masking solution with a finger to reveal the white paper or earlier color (right).

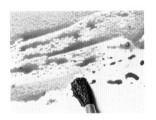

Masking fluid—clouds

Apply the masking fluid and wash in the same way as for trees, but use a medium to large brush and broad, loose strokes.

Turpentine

Painting an area with turpentine before applying a wash produces exciting but unpredictable effects.

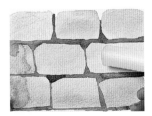
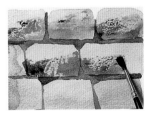

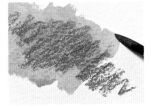

Candle wax

Rub a clear wax candle over the areas to which you wish to add texture (left). Watercolor or ink washes will resist settling in those areas that have wax on them (right).

Oil pastel

Oil pastel will partially repel a wash of ink laid over it.

Papers

Paper is the most usual support for drawing—it is cheap, light, and available in a range of weights, textures, and colors to suit most drawing media and tastes. Different drawing papers suit different drawing media; for example, a pen will draw best on smooth paper, while chalk, pastel, and charcoal need a rougher surface—what is often described as a paper with some "tooth." There are special colored papers for pastel drawing that have a distinct texture; they can also work well for charcoal or conté.

Watercolor paper is available in three finishes: Hot-Pressed, Cold-Pressed (or Not), and Rough. Hot-Pressed has a very smooth texture, and is more often used for drawing or ink and wash work; Cold-Pressed paper has a slightly textured surface; Rough paper has quite a grainy surface. Watercolor paper is generally white, because the paper itself will establish the lightest area of the painting or drawing.

Watercolor paper *Watercolor paper is woven, acid-free, and usually white. It comes in degrees of thickness and in three different textures: Rough, Cold-Pressed (also known as Not), and Hot-Pressed. Machine-made watercolor paper is the most usual choice, and is relatively inexpensive. Mold-made papers are more durable, and less resistant to distortion. The best, but most expensive, type is handmade.*

Drawing paper and pads *Drawing paper is available in a range of weights and comes in sheets, rolls, pads, and sketchbooks. Its primary use is for drawing with dry media and ink; it is not suitable for pastel, charcoal, or watercolor.*

Daler
Series 'A'
Cartri
Pad
Size A

GALLERY

Pastel sheets and pads

Most pastel artists use specially textured pastel papers that will hold several layers of dry pastel dust without becoming saturated. Pastel papers are available in a wide range of colors (right). The color of the paper influences the effect of the applied pastel colors (left).

Watercolor pads

Watercolor paper can be bought in separate sheets or in pads or sketchbooks of varying sizes.

Acetate and tracing paper

Tracing paper is used to transfer drawings from one surface to another, while acetate is often used to make up grids (see page 46).

PAPER GRAIN

Compare these colored-pencil marks to see the effect of the surface texture of the paper on the media.

Drawing paper *Pastel paper* *Heavy watercolor paper*

Getting started

You don't need an extensive array of materials to begin drawing. It is better to start with as few as possible so that you don't misplace them or waste time deciding which to use. Your basic kit need consist of no more than a few pencils of various grades, an eraser, and a sketchbook—or a drawing board and paper if you like to work on a large scale. As you progress, you may want to add a light folding chair and an easel to your kit, and a hat if working in bright sunlight. For outdoors, take a plastic bag to protect your work from the rain. To avoid forgetting anything, make a checklist before you start. It is extremely frustrating to arrive at your destination and find you have forgotten the pencils or the eraser.

To avoid frustration when drawing outdoors, make a list of the materials and equipment you need to take with you.

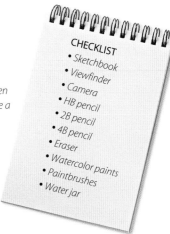

CHECKLIST
- Sketchbook
- Viewfinder
- Camera
- HB pencil
- 2B pencil
- 4B pencil
- Eraser
- Watercolor paints
- Paintbrushes
- Water jar

Drawing tips

A very useful drawing aid is a viewfinder, which helps you to decide on the viewpoint and composition (see page 90). You can make one by cutting a rectangular hole in a piece of cardstock, or by overlapping two L-shaped pieces to form a rectangle. When you look at a large expanse of landscape, it can be hard to decide how much to include, but the viewfinder acts as a frame, isolating parts of the landscape.

If you still cannot decide on the composition, even with a viewfinder, make several small line drawings, trying different arrangements. This tends to focus the mind and get your imagination going, and the end result is often better than if you charge straight in. Above all, don't worry if your first attempts are disappointing; drawing requires practice, and you will succeed if you keep at it.

Three grades of pencil, an eraser, and paper clipped onto a drawing board are all you need to get started.

Take some photographs of the view as a reference aid for when you get home.

The role of the camera

Many artists take their cameras with them when sketching outside in case the weather changes or they cannot finish in time. It is wise to follow their example; few people now regard the use of photographs as cheating. Photos provide a useful backup to a half-finished sketch. In addition, there are some subjects that you cannot draw on the spot; there may be nowhere to sit, or you may just be passing through a place on vacation and not have time to stop. On the following pages, you will find advice on how to make an accurate drawing from a photograph.

ARTIST'S TIP

When choosing a medium, think about the purpose of the drawing. If you just want to make a few quick sketches, work on a small scale, in a sketchbook, with a pencil or pen. Many artists use a few sticks of pastel and a pencil, so that they have both line and color. Pastels are messy, so include wet wipes or a paper towel in your kit to clean your hands. Pastel pencils are less messy and perhaps more convenient for outdoor work. The size at which you wish to work is important, even in a sketchbook. Filling a large area with solid slabs of colored pencil is time-consuming and tedious. For large-scale work, choose watercolor or a brisk medium like charcoal, which has a very responsive line.

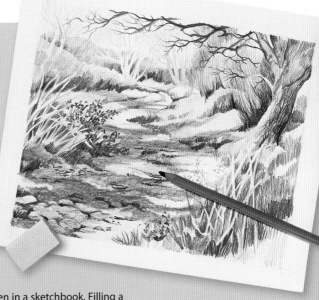

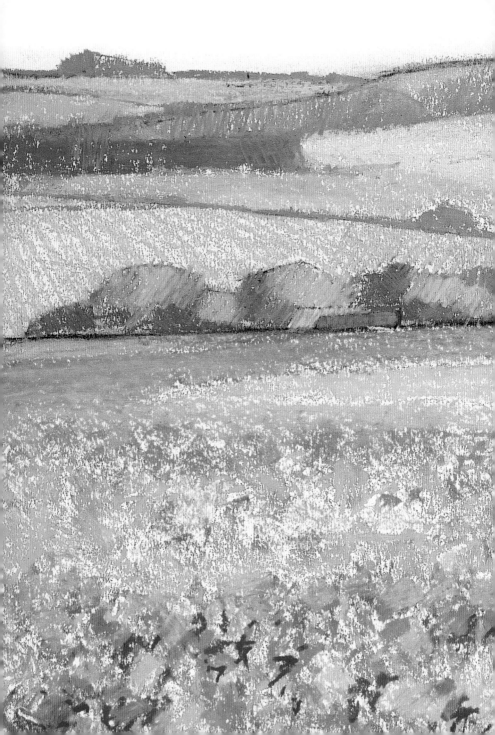

2
Techniques and tutorials

Clear, step-by-step, visual instruction
on how to draw landscapes

Simple shapes

Most successful paintings and drawings are based on simple shapes, such as squares, circles, ovals, oblongs, and so on. You cannot always identify these in a finished drawing, but they are there as underlying "hidden" shapes, so try to look for these in the landscape before you start to draw. The variety of shapes in a landscape can be overwhelming when you first start to sketch, and you will be further confused by tones and colors, and by changing light, all of which can obscure the main shapes. However, with practice you will learn how to ignore the details, look for the main shapes, and simplify them when you are composing the drawing.

Practice looking for the hidden simple shapes in a scene. Place an overlay over a photo and draw the main shapes with a pencil.

Using a grid

If you are working from a photograph, you may find it helpful to use a squaring-up method to make your drawing. Take a piece of cardstock roughly 5 x 7in (12.5 x 18cm) in size and cut a hole in the center to match the size of the photo. Fix

a piece of fairly stiff transparent material over the back of it and rule this up into ⅝in (1.5cm) squares with a permanent fiber-tip pen. If you lay this over the photo and then rule larger squares on the paper—you can decide on the proportions you want—you can accurately transfer the information from the photo to the paper. This grid-type viewfinder is also useful for checking proportions and angles when working outdoors.

ARTIST'S TIP

It is important to compare shapes and directions when you draw. Usually people see objects in isolation; for example, landscape is seen as first one tree, then another, and then a background. As an artist, you need to learn how to see and compare all these features simultaneously, and use background features as a check for shapes.

Thumbnail sketches

It may sound laborious to make small sketches before embarking on the main drawing, but it is helpful, because it can save you having to make changes later. The more preparation you do, the more chance you have of achieving a successful drawing. Sketch in the main shapes and tonal values, restricting the tones to no more than five—or as few as three if possible. These thumbnail sketches will concentrate the mind and highlight possible mistakes that could result in your having to make major changes to correct the work.

When you begin on the drawing, simplify brushstrokes and pencil lines so that the viewer is not confused as to what the drawing is about, and leave detail until last when you can decide how much to include. Sometimes you will need very little, so do not try to draw in every cloud, every leaf or branch on a tree, or every ripple on water. These are usually just as effective, or even more so, if they are merely suggested rather than treated literally.

To avoid basic mistakes in the composition, make a quick sketch of the main shapes. Making a few tonal sketches, restricting yourself to between three and five tonal values, will also prove invaluable when you come to embark on the main drawing.

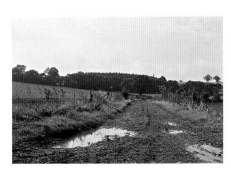

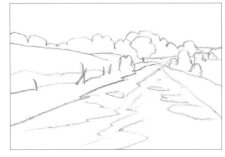

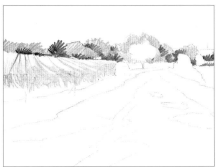

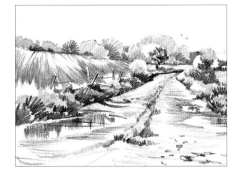

Tutorial **Country lane**

When you are sketching outdoors directly from the subject, you will see a lot more than is reproduced in a photo, so you may have to be selective. However, one of the advantages is that you can move around and explore different viewpoints and compositional possibilities. To make a better composition, the artist has widened the path leading into the drawing and slightly altered the smaller tree on the left. Remember that on a sunny day the pattern of light and shade will alter dramatically, so if cast shadows are important, as they are in this drawing, make a note of their shapes in the first stage of the drawing and don't be tempted to alter them later, because this will cause problems with the other areas of the drawing.

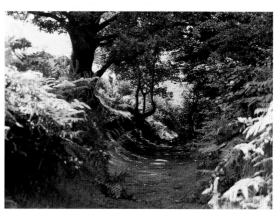

Reference photograph

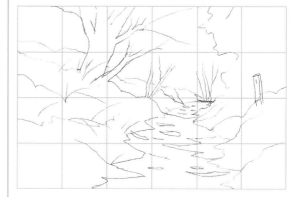

MATERIALS

- *Drawing paper*
- *HB pencil*
- *Range of soft graphite pencils from 3B to 9B*
- *Plastic eraser*

1 Make a simple outline drawing with an HB pencil, using a grid to help you mark the main shapes accurately. Keep the lines fairly light, because most of these will not be wanted in the finished drawing and they will be erased later. To help you draw the main tree correctly, look for the "negative" shapes where the sky shows between the branches. These shapes are simpler than the "positive" ones of the trunk and branches, and are a useful double-check when drawing. Indicate patches of sunlight on the lane.

2 Beginning at the top of the drawing and working from left to right or vice versa to avoid smudging, start shading in the foliage. Make diagonal strokes to suggest grasses and nonspecific foliage, varying the angles and finishing with dots and tiny squiggles at the top. Once some tone has been filled in behind the trunk, the main tree becomes a simple light-against-dark shape, making it easier to "read."

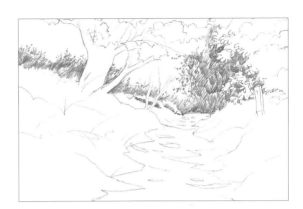

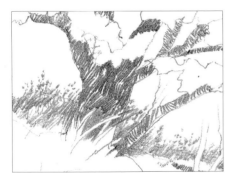

3 Change to a 3B pencil to shade the large tree. Leave the foliage clumps white, and erase the lines of the tree where they go through the clumps.

4 Draw the small trunks at the far end of the lane, and deepen the tone slightly behind them so that they don't stand out too much. Put in more shading in the negative space behind the outlines of the larger leaves on the right-hand tree; this will be left mainly light against dark. Once the dark tones in the background are established, it will be easier to decide how to balance them with shadows and other dark areas in the foreground.

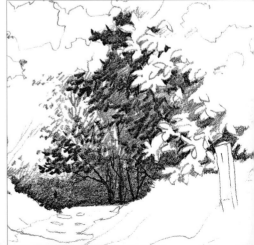

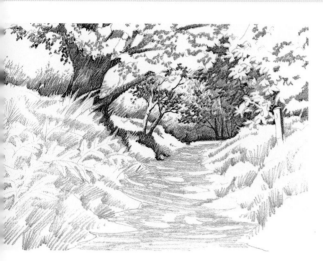

5 Using an HB pencil, shade in the lane, with long strokes going slightly up at the edges to give the impression of the upward curve. To suggest form and texture on the banks, use mainly short strokes. Lightly draw the main veins of the ferns, then shade around them to make them stand out. Using 3B to 9B pencils, add more tone to the large tree trunk, then build up the background foliage and shade in the small silver birch.

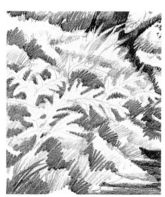

6 Use a 3B pencil only to build up the tonal pattern of the foreground. Deepen the tone behind some of the bracken on the banks, but remember to leave areas of the paper white to suggest dappled sunlight.

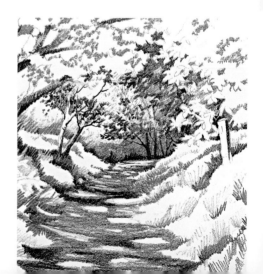

7 To make a strong light/dark contrast in the immediate foreground, continue the tree shadows across the track. This also helps to unite the foreground and middleground. If you find you have left too many sunlight patches on the lane, some can be toned down later.

8 Too many lights can create a confused, jumpy impression, so blend back some of the left-hand foreground areas with an HB pencil. Deepen the tone of the trees at the end of the lane so that the shapes of the light leaves stand out well. Darken and thicken the main shadow, shading over one or two of the light patches, and taking the shadow up the right bank to unite the left and right sides of the drawing. The addition of some puddles in the lane helps to suggest sunlight after a squall of rain. Shade the small reflections with vertical strokes, using two tones for variety.

Tutorial **Arizona landscape**

This powerful subject, with its strong, dramatic shapes and contrasts of tone, is well suited to a monochrome treatment. However, the artist has decided to work with brown rather than black conté crayon because it gives a better "feel" of the hot colors of the landscape. He has changed the composition slightly from that seen in the photograph, first by leaving out the small central bush and its shadow, and second by simplifying the remaining foreground bushes so that they make a horizontal line at the front of the picture plane. This makes the composition more powerful by dividing it into three distinct bands, with the rocks as the dominant feature.

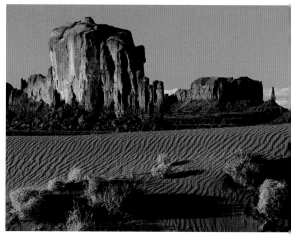

Reference photograph

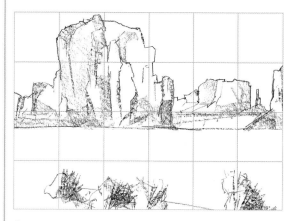

1 Start by making an outline drawing of the main shapes, using a corner of the conté stick, which will make a sharp line. If you make a mistake, lift out the incorrect line with a kneadable eraser. When you are satisfied with the outlines, begin to indicate the paler tones on the rocks and bushes using the conté stick on its side. For the foreground foliage, combine side strokes with sharp lines to give an indication of both forms and textures.

MATERIALS

- *Drawing paper*
- *Brown conté stick*
- *Kneadable eraser*

2 Start to build up the tones, paying attention to the shapes of the shadows, because it is these that describe the structures. The central crevice of the large rock and the rectangular shadow on the right-hand rock provide verticals to balance the horizontal band below. Lightly cover the side of the rock structures with conté to suggest texture.

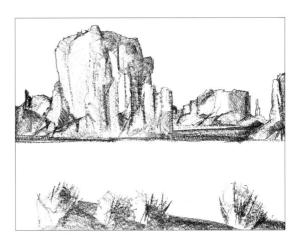

3 Use firm pressure to deepen the shadow areas of the scrub. Draw in a smaller bush behind the left-hand bushes to break up the large expanse of sand and lead the eye in toward the rocks.

4 Heighten the contrast by building up the darkest shadows. Indicate the texture and pattern of the sand by sketching in the sand ripples loosely. The sand links the rocks and foreground, but treating it in too much detail would weaken the composition.

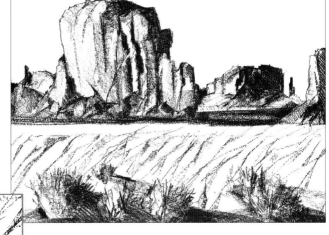

Tonal values

The word tone, or value, simply describes the lightness or darkness of any color, regardless of its hue. Tonal values would be easy to identify if the world were seen in monochrome, but color complicates the issue, because it registers so strongly. It is important to be able to assess value, because drawings with little or no tonal contrast look dull and bland (the exception being line drawings, which rely on the quality of line for their impact).

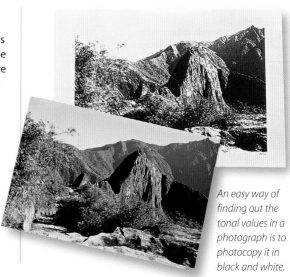

An easy way of finding out the tonal values in a photograph is to photocopy it in black and white.

Identifying tonal values

Values are not always easy to identify, because the color of an object is what we first see. To calculate the tonal values in a subject, it is helpful to look at it through half-closed eyes, which cuts out some of the detail and reduces the impact of the color. Making a tonal value chart is another way of avoiding mistakes and is especially useful in sketching with color, where it is easy to get the values wrong. To check whether a value is dark enough, hold up the chart and close one eye, select the value in the chart that is closest to the one required, and place the equivalent color on your drawing. Often you will find you have not made it dark enough.

To make a tonal value chart, divide a sheet of watercolor paper into 10 even squares and number them 1 to 10. Leave the first square white. Using burnt umber or Payne's gray, paint the second square in a very light tone and gradually darken the following squares until number 10 is as dark as possible (you may need two coats for this).

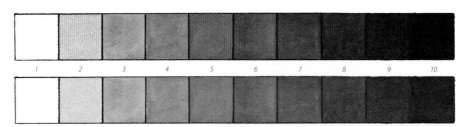

Color values

Some colors are lighter in value than others. For example, yellow is always at the light end of the scale, and most blues and purples, if undiluted, are toward the dark end. These differences are known as tonal ranges; the darker you can make the color (undiluted), the greater the value range. You need to understand this in order to darken color mixtures, which you can do with those that have a long tonal range, such as Payne's gray, burnt umber, and indigo, but not with the yellows and pinks, which have a short value range.

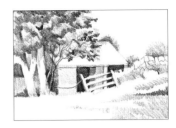

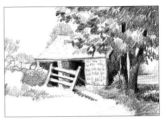

Note the effect of the light on the same scene sketched throughout the day. The long evening shadows in the third sketch add extra contrast and tonal value.

Hold your tonal value chart up to the view and make sure you pick the right value. It is a common mistake to make the value too light.

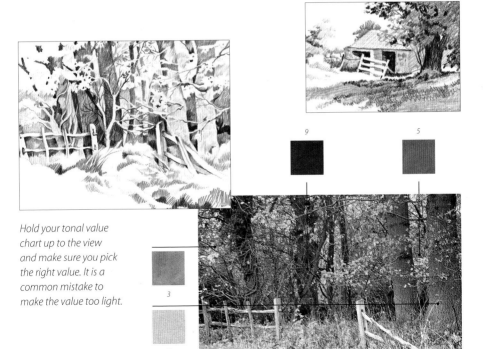

Tutorial **Mountain view**

This photograph of Yosemite National Park in California was taken on a slightly hazy day, which has simplified the details and reduced the tonal contrasts. To give the drawing more punch, the artist has strengthened the light to enable her to exploit the interplay of light and dark tones. This is easy enough to do; just decide where the light is coming from and make the shadows consistent. You will often have to do this when sketching outdoors, because weather can change rapidly, and even if it stays sunny, the sun moves constantly, completely changing the shadows and tonal patterns.

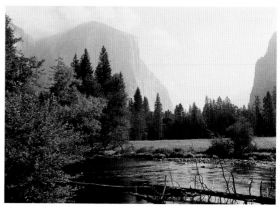

Reference photograph

ARTIST'S TIP
You can see a great many values in nature, but if you try to include them all, your work will become either confused or dull, possibly both, so try to identify the main values. Initially, you could start by dividing the composition into just three main values: light, medium, and dark. Pay special attention to the focal point of the picture, because you want sufficient value contrast to emphasize it.

1 Think about the composition before you start and decide whether you might leave a few things out. The fallen tree trunk in the water does not help the composition, and the foreground area would be strengthened by adding some dark reflections. The mass of foliage in the left foreground is quite confusing, because it is so near that you can see the individual leaves rather than the main shape. Exercise artistic license to turn it into a simple shape. Draw the main shapes lightly with an HB pencil.

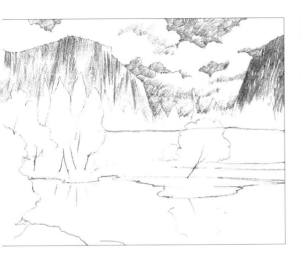

MATERIALS

- *Drawing paper*
- *HB pencil*
- *3B pencil*
- *9B pencil*
- *Plastic eraser*

2 Begin the shading, starting at the top of the picture. Keep the tones fairly light, but take care to establish the really light areas by placing them next to a middle tone. Notice how the cliff against the sky goes from dark against light at the top to light against dark on the right side. This is known as counterchange and is very important in tonal drawing.

3 Start to put in some of the dark tones that will help you to build up the overall tonal pattern of the drawing. Shade in the conifers with an HB pencil, changing to a 3B for the ones against the right-hand cliff. Don't make the tones so dark that you will be unable to add more on top for the shadowed area; even these dark trees are lighter on the side where the light strikes. Balance the darks of the trees with a dark shadow at the edge of the river bank.

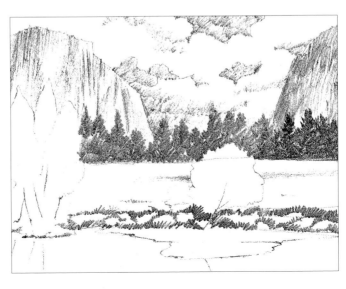

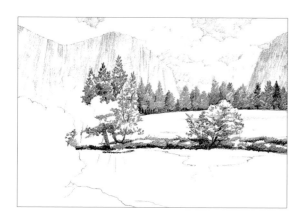

4 Begin building up tones on the trees in the middleground, using larger and more positive pencil marks, because these are nearer to you than the conifers, and you can see more foliage detail. Draw in the trunks and lightly shade behind them. Leave some of the trunks as mid-tone negative shapes. Darken the tones in a few places along the river bank using a 3B and then a 9B pencil.

5 Start developing the foreground and adding details. Draw in some stones beneath the water in the foreground and draw smaller stones on the bank beyond, darkening behind some of those nearest to the water.

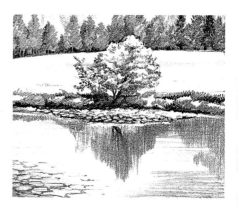

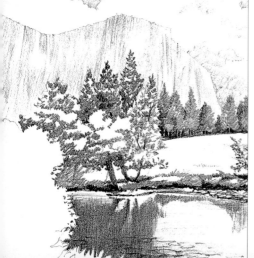

6 Draw in one or two leaf shapes on the left-hand foreground tree and then shade the water behind, using first horizontal and then vertical strokes. Draw the reflections with an HB pencil, using vertical strokes and making the reflected tree trunks darker than the surrounding areas.

7 Apart from a few final touches, all that now remains is to draw in the foreground tree. Like the cliff and sky, this tree and the one behind it are an example of counterchange, with the light edge of one set against the dark area of the other. The artist has deliberately exaggerated this effect; if you look back at the photo, you will see that the tree was quite formless, with little or no tonal contrast to separate it from the one behind.

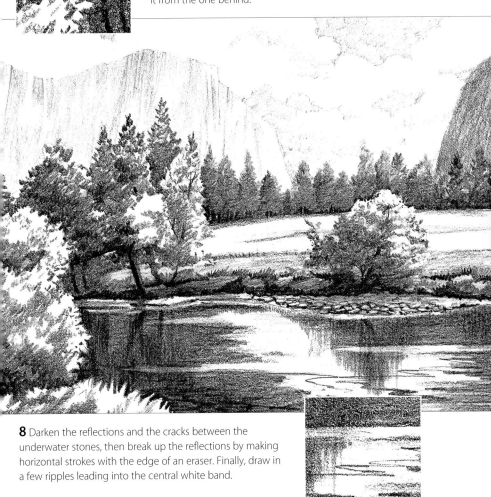

8 Darken the reflections and the cracks between the underwater stones, then break up the reflections by making horizontal strokes with the edge of an eraser. Finally, draw in a few ripples leading into the central white band.

Tutorial **Shallow river**

The shallowness of the water allows you to see the stones on the stream bed in the foreground, which make an interesting feature to draw. The bright sunlight provides a strong tonal pattern, with the pale shapes of the stones and the light bouncing off the water in the foreground contrasting with the darker areas of water. The strongly lit tree on the bank, which is the focal point of the composition, is set against the dark trees behind, producing counterchange—the lightest tone against the darkest. Counterchange is very important in tonal drawing, because it adds depth and impact. Texture is also an important theme in this drawing, with the smoothness of the rocks and water surface contrasting with the roughness of the trees. As you build up the drawing, think about how you can use the pencil marks to suggest the textures without becoming too fussy.

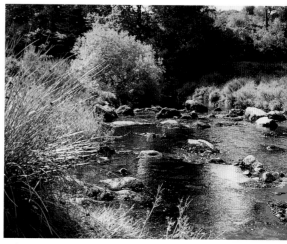

Reference photograph

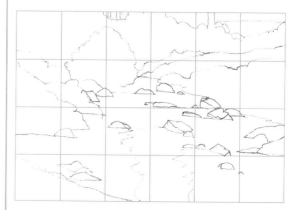

ARTIST'S TIP
Vary the sizes and the spacing of shapes such as rocks, stones, trees, or fields to give your work more interest.

1 Make an outline drawing using an HB pencil, looking for the main shapes and trying to simplify the rocks slightly to avoid a cluttered look. You can add more detail later if needed, but if you put in too much at the beginning, you may become confused. Look for the angle at which the rocks are set, keeping in mind that water has a horizontal plane. Sketch in the light areas where the sun strikes the river in the foreground.

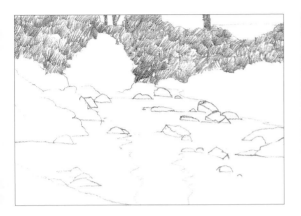

MATERIALS

• *Drawing paper*
• *HB pencil*
• *2B pencil*
• *3B pencil*
• *9B pencil*
• *Plastic eraser*

2 Shade in the area of dark tone at the back of the drawing. This is a large area to shade, so try to be consistent with your pencil strokes so that it does not appear muddled, but vary the tones a little by increasing the pressure in places.

3 Change to a 3B pencil and put in the second tone on the background bushes to build up the counterchange. Where there is a strong, dominant area of dark tone, it is wise to establish this at an early stage, because it will provide a key for judging the strength of tone needed for the smaller dark areas in the middleground and foreground. Use more varied marks to suggest the forms and textures of the foliage, and leave patches of the original middle tone showing. Use an HB pencil to shade in the tussocks of grass on the left bank.

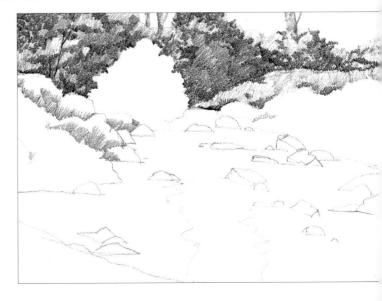

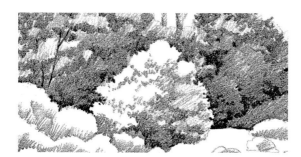

4 Still using an HB pencil, texture the main tree, varying the marks from long hatching strokes to short squiggles. Leave white paper on the left side and top, where the sun strikes. To pull the tree forward, darken some areas behind it with a 3B and a 9B pencil.

5 Using an HB pencil, shade in the right bank, using marks that follow the directions of the clumps of grass. Make the marks shorter in the distance to suggest recession. Draw in the bottoms and shaded sides of the rocks. Loosely draw in the foreground grasses, using a double line for each blade.

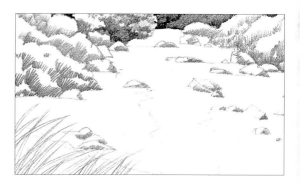

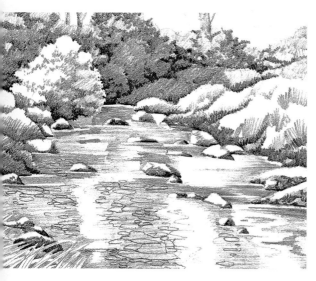

6 Deepen the second tone on the banks to throw the light surfaces of the rocks into relief. Put the first tone on the water, making horizontal strokes with an HB pencil and shading behind the foreground grasses. Make the strokes shorter in places to suggest the way the rocks break the surface. Draw in some of the underwater rocks and stones, varying the shapes and fading toward the light areas. Begin to work the dark and middle tones on the rocks and water.

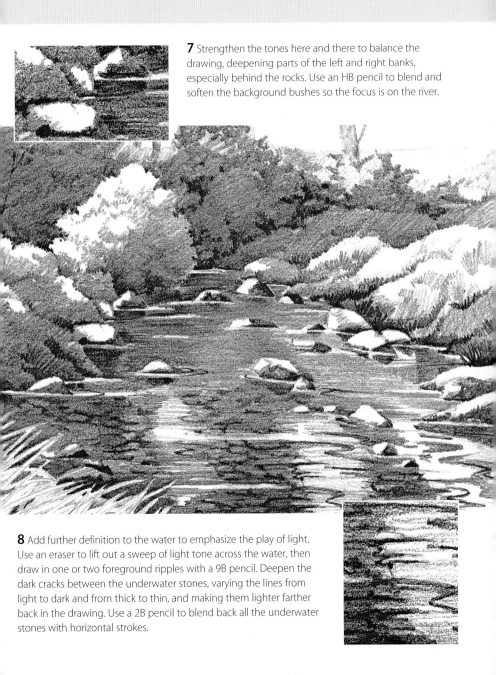

7 Strengthen the tones here and there to balance the drawing, deepening parts of the left and right banks, especially behind the rocks. Use an HB pencil to blend and soften the background bushes so the focus is on the river.

8 Add further definition to the water to emphasize the play of light. Use an eraser to lift out a sweep of light tone across the water, then draw in one or two foreground ripples with a 9B pencil. Deepen the dark cracks between the underwater stones, varying the lines from light to dark and from thick to thin, and making them lighter farther back in the drawing. Use a 2B pencil to blend back all the underwater stones with horizontal strokes.

Tutorial **Farm road**

In this pen-and-wash sketch, watercolor has been used for the tone and a fountain pen with black Chinese ink for the line. Chinese ink is sold in the form of a solid tablet and is very easy to use, but if you cannot obtain it, any water-soluble black ink will do. Keep the initial outline drawing as simple as possible when working in ink, because you cannot erase it. If you are not confident about drawing directly with a pen, draw the outline with an HB pencil, which you can erase later if necessary. There are different ways of approaching pen-and-wash drawings. Some artists complete the line drawing before adding tone, while others reverse the process, drawing over washes. Here, the two are used together.

MATERIALS

- *Drawing paper*
- *HB pencil (optional)*
- *Fountain pen*
- *Black water-soluble ink*
- *Watercolor paint: Payne's gray or indigo*
- *Small round brush*
- *Long-script liner brush*
- *Medium to large round brush*

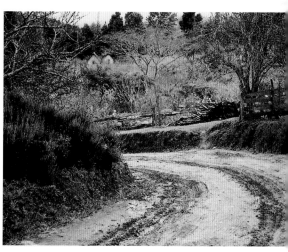

Reference photograph

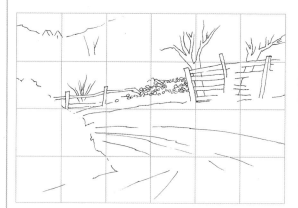

1 Figure out the composition before you start to draw—make a couple of rough sketches if you are unsure of how to treat the subject. Here, the artist has cropped the path at the front of the composition to make more of the trees, fence, and pile of logs, which she saw as the main points of interest. Cropping the path also provides a strong near-diagonal that leads the eye into the picture.

2 Mix up a dark and a middle tone of either Payne's gray or indigo and start painting from the back, damping the background first with clean water. With the lighter mix and a round brush, wash in the small area of sky. While still slightly damp, put in the trees with the darker mix. Allow to dry, then paint the field with a varied wash of the lighter tone. Leave the tree tops on the right white, and paint in between the fencing. Dampen the area for the right-hand bank and work wet-in-wet as for the sky and trees, dropping the dark tone into the lighter one.

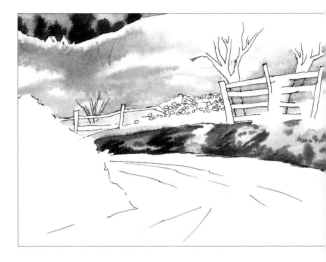

3 Reinforce the line drawing using pen and black ink. Draw in the branches and twigs, taking care not to make them all follow the same direction; some branches come toward you, while others bend away. Shade the tree trunks fairly heavily,

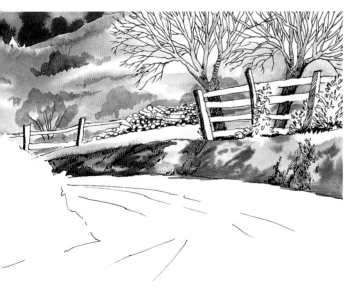

suggesting the textures with varied lines, then darken the shadowed sides of the fence posts to give them form. Draw some foliage on the banks, and darken around the log ends. Using the lighter of the two watercolor tones, paint in a few background bushes, and lay the same tone over some of the branches of the foreground trees.

4 Work the next two stages in tone alone, so mix up more of the first two tones if needed and then mix a third, very pale tone. Work the left bank wet-in-wet, using the middle and dark tones, and while the paper is still damp, pull out a few grasses with a long-script liner brush.

ARTIST'S TIP

If you want to build up tones quickly in a drawing, you have two basic options. You can either lay the areas of tone with a water-based medium and a brush, as in this tutorial, or choose a soft, easy-to-smudge medium such as charcoal or conté crayon. Neither of these is ideal for outdoor sketching unless you work on a large scale. Charcoal, for example, can smudge more than you want and make a mess of your hands. However, for studio work, both can produce exciting results.

5 Wash over the path with the pale tone, using a medium to large brush. While still damp, sketch in the tracklines with the medium tone, changing to the dark one as the tracks come toward you and widening the lines. Allow to dry.

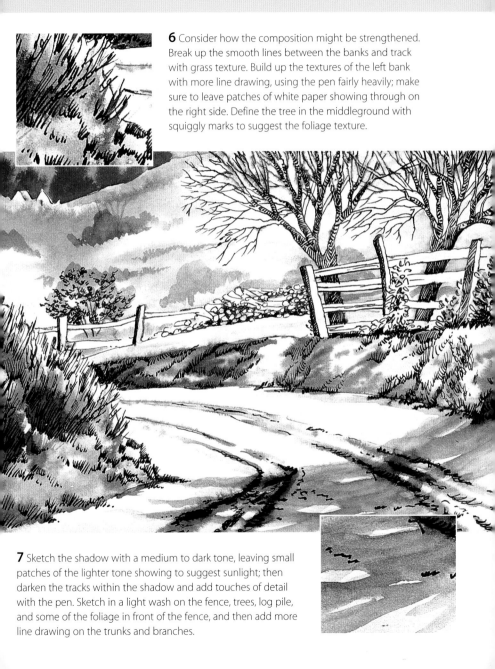

6 Consider how the composition might be strengthened. Break up the smooth lines between the banks and track with grass texture. Build up the textures of the left bank with more line drawing, using the pen fairly heavily; make sure to leave patches of white paper showing through on the right side. Define the tree in the middleground with squiggly marks to suggest the foliage texture.

7 Sketch the shadow with a medium to dark tone, leaving small patches of the lighter tone showing to suggest sunlight; then darken the tracks within the shadow and add touches of detail with the pen. Sketch in a light wash on the fence, trees, log pile, and some of the foliage in front of the fence, and then add more line drawing on the trunks and branches.

Using color

With many subjects, including landscapes, the thing that you notice first is the color. As well as providing drawings with an additional descriptive element, color has other uses. It can be used in drawing to enhance the illusion of three-dimensional space and it can be used to express emotions. Many students of drawing are reluctant to begin color work because they anticipate difficulties. In practice, making colored drawings is easier than most people expect it to be; in monochrome media, you have to allocate a tonal value to each color, in order to represent it, but in color, you simply draw what you see. Mixing colors to match observed values becomes less daunting when you choose a palette with sufficient range to create all your required shades.

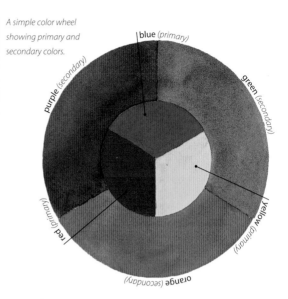

A simple color wheel showing primary and secondary colors.

blue *(primary)*
purple *(secondary)*
green *(secondary)*
red *(primary)*
yellow *(primary)*
orange *(secondary)*

ARTIST'S TIP

A relatively small range of colors is needed for pre-mixing in either inks or washes, because the permutations that are possible create many variations of hue. The surface mixing required in dry drawing media, such as pastels and colored pencils, is less easy to accomplish. Such linear media make narrow marks, so adopt an accumulative technique, such as hatching or crosshatching, to build up a body of color. Strokes applied separately will be seen as a composite shade at a distance.

Color relationships

The color wheel demonstrates the relationships between colors. The three primary colors are red, yellow, and blue; the three secondary colors are orange, green, and purple. The secondaries are made by mixing two primaries together. Each primary has a secondary that is said to be "complementary" to it opposite on the wheel—purple, for example, is a mixture of blue and red and is the complement of yellow. Using complementary colors is always effective in a drawing, because they set up vibrant contrasts (think of red poppies in a green field). They are also useful in mixtures: a touch of green added to a red, for example, will dull it down without muddying it. Colors in the same part of the spectrum (blues and greens, reds and oranges) are said to be "harmonious" and generally evoke a calm mood.

The properties of color

Any color has three basic properties—its hue, its tone, and its intensity. Hue means the color as identified by its name—red or blue, for example. Tone means the lightness or darkness of a color. You can, for instance, have a light blue or a dark blue. In addition to the properties of hue and tone, colors have varying degrees of intensity. Two reds may be identical in tone and yet be clearly different, with one more intense, or brighter, than the other. This difference in intensity is sometimes called color saturation.

When you use the word color, you are generally referring to these three properties—hue, tone, and intensity—simultaneously. However, it is helpful to be able to identify them separately, because when you notice that a color is "wrong," you will be better able to pinpoint what is wrong with it—whether it is too light in tone or too intense.

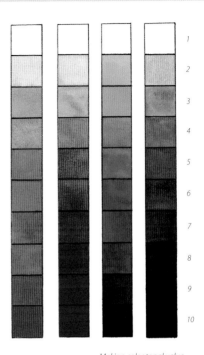

1
2
3
4
5
6
7
8
9
10

Making color tonal value charts in a range of different colors is a very useful exercise, because it will help you improve your control of colors and tones. Follow the instructions given on page 54.

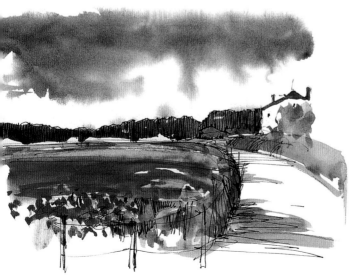

The bright splash of red in the poppy field contrasts well with the gathering storm clouds behind.

Tutorial **Poppy field**

There can be few more enticing landscape subjects than a field full of poppies in full flower. A natural complementary contrast is provided by the red of the flowers set against the greens of surrounding fields and hills. Oil pastel is an excellent medium for such a subject, because rich, deep colors can be built up very quickly by using heavy pressure on the sticks. However, in this case the artist has decided to work relatively lightly, using a higher color "key" to suggest sunlight rather than reproducing the rather dark, heavy colors in the photograph. He is working on pastel paper, and has let the paper show through the pastel strokes in places to enhance the light, airy effect.

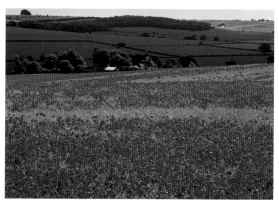
Reference photograph

MATERIALS

- *Pastel paper*
- *Charcoal pencil or stick of willow charcoal*
- *Oil pastels: cobalt blue, pale blue-green, indigo, pale yellow-green, red, red-orange, orange (light and middle tones), yellow, olive green, pink (light and middle tones)*

1 Use charcoal to sketch the main lines of the composition. Avoid splitting the composition in half by placing the dividing line between foreground and background so that the poppy field takes up two-thirds of the picture space. Add color to the sky and fields, keeping the pastel strokes light so that the paper shows through. Keep the colors relatively cool in the background, using cobalt blue as an undercolor for the more distant fields and pale blue-green for the nearer one, above the trees. Keep the direction of the light in mind, and shade the dark sides of the trees with indigo.

2 Work on the foreground next, to complete the main color framework. Use the pastel sticks on their sides to make broad strokes of pale yellow-green to indicate the grass between the flowers. Make the color slightly darker toward the front of the picture. Use the side of a red-orange pastel stick to suggest the poppies, but make shorter strokes than those used for the grass and vary the pressure from light to medium.

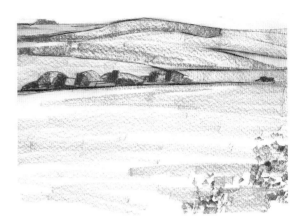

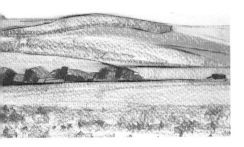

3 Continue to build up the colors. Lay a mid-tone olive green over the indigo of the middleground trees to warm the sunlit sides of the trees, using fairly light pressure. After defining the middleground trees, you can begin to strengthen the pattern of the background fields, laying on the same mid-tone olive green.

4 Strengthen the colors of the poppies with oranges and yellows, putting in touches of pink to suggest the fall of light. Suggest the shapes by varying the pastel marks. Use the same yellow-greens as before for the grass, but increase the pressure to build up the depth of color.

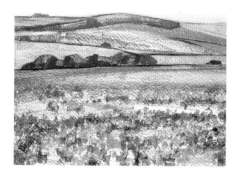

5 Build up the tonal contrasts in the poppy field with stronger reds in the foreground, and light oranges and pinks for the distant poppies. To maintain the red/green complementary color theme, use red-orange overlaid with pale blue for the barn roofs. This is more harmonious than the stark white seen in the photograph. Add the trees in the distant fields, making them paler and bluer than the middleground trees.

6 For the grass in the middle distance, make long strokes of yellow-green, applying medium pressure. This vivid color enhances the sunlit effect, and contrasts with the blue-greens of the background fields and hills.

7 To help the poppies stand out, darken the greens around them to suggest their shapes and areas of grass. Use olive green at the very front and a mid-tone gray-green farther back in the field. This warm green, together with the deep red, pushes the cooler colors of the fields back in space to help create the illusion of recession.

8 Adjust the colors and contrast in the background, laying a pale warm gray all over the central field to alter the tone and help the area to recede. Using diagonal strokes to contrast with the horizontals below, add varying greens, blues, and grays to heighten the contrast and suggest the "stripes" of the fields. Fill in the distant clump of trees more solidly with blue-gray, and work yellow ocher over the trees around the barns. In the foreground, add yellows to the grass between the poppies, and darken some of the flowers with a deeper red.

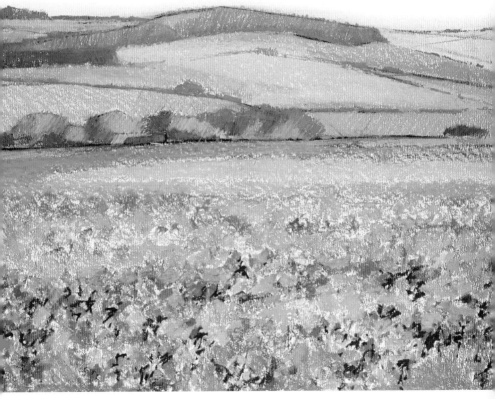

Tutorial **Red cliffs**

The soft, late-afternoon sunlight gave this landscape an attractive delicacy well suited to a line-and-wash treatment. The artist has used pencil for the line rather than the more usual pen and ink, because this gives a softer effect as well as enabling her to build up tones before applying the washes. The fading colors of the foliage in the scrubland and on the trees blend gently into the gray pencil tones used for the tree tops and twiggy sage bushes. The red of the cliffs has been deliberately toned down to prevent them from coming forward and destroying the sense of space. All of the shapes in this drawing are organic, so you can have some fun and paint either wet-on-dry or wet-in-wet (or both), because it does not matter if colors bleed into each other or if a wash dries with a hard edge.

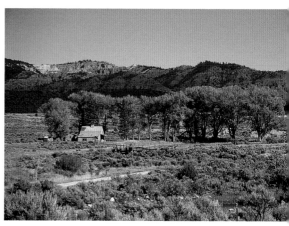

Reference photograph

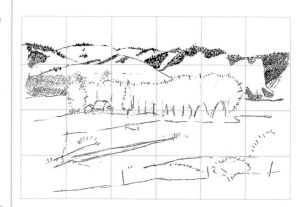

MATERIALS

- *Watercolor paper*
- *6B pencil*
- *Watercolor paints: cadmium yellow, yellow ocher, cerulean blue, cobalt blue, light red, sap green, French ultramarine, viridian*
- *Small round brush*

1 Sketch in the main features in pencil. To position the trees, make small marks in the direction of the branches rather than drawing the whole outline. This allows you to make adjustments more easily. Remember that you can make changes to improve the composition, such as removing some of the scrub in order to see slightly more of the track and fencing. Begin to build up the tones on the mountains, hatching them with diagonal strokes. Block in the dark coniferous trees on the mountain tops as small triangles of varying shape and size.

2 The main center of interest is the line of trees and farm buildings, with the mountains forming a dark backdrop. At this stage, render the group in medium tones, drawing in the tree trunks, branches, and buildings, then start adding shadows. Draw in the strata and fault lines on the cliffs, noticing how the horizontal lines slip down at the faults.

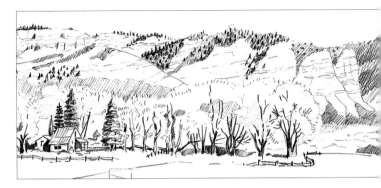

3 Draw in little overlapping hummocks for the sage bush in the scrubland in front of the farm; shade in the base of each hummock so that the top edge is highlighted against the bush behind. Draw in the foreground fence; this plays an important part in the composition, because it leads the eye in toward the other fence and the buildings behind it.

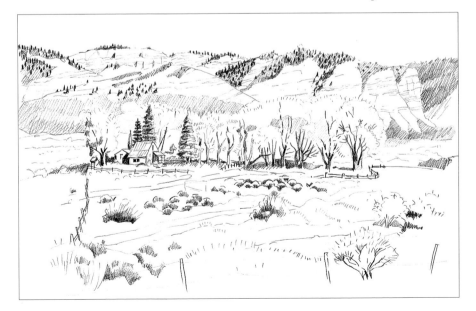

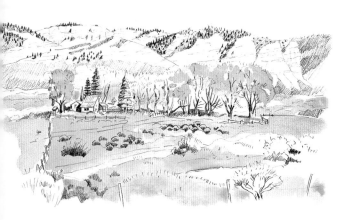

4 Mix a very dilute solution of cadmium yellow and yellow ocher, and lay the first wash over the foreground and middlegound. Don't worry if the wash is not flat, because small variations will enhance the impression of freshness and spontaneity. For the sunlit areas of the trees, use a stronger mix, mainly of cadmium yellow. Allow it to dry.

5 Mix a weak wash of cerulean blue and cobalt blue for the sky area, and paint this same color over the tree-clad parts of the mountains to make them fade gently into the sky. Add a wash of light red to the cliffs; this will be the highlight color.

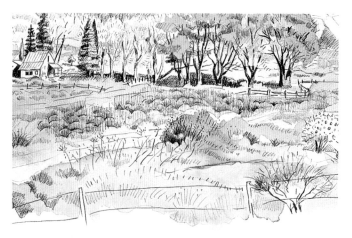

6 Draw in more detail in the foreground, indicating bushes, twigs, and dead flower heads. Knock back some of the pencil detail in the scrubland by adding vertical hatching to some areas; this has the effect of linking and softening the details. Add touches of sap green to the scrubland bushes.

7 Continue to add stronger touches of color. Mix French ultramarine and sap green for the distant coniferous forest, paint a wash layer, and add some tiny tree shapes that bleed into the shadows. You can also use this mixture for the cast shadows under the main trees and house. Add touches of sap green to the trees. Build up the strata of the cliffs with successive layers of light red.

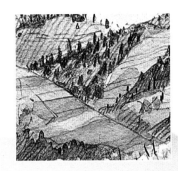

8 Paint the roof of the house with dilute viridian, and the walls with a mix of yellow ocher and light red. Using various mixtures of yellow ocher, light red, and sap green, wash in the shapes of the foreground shrubs and trees over the structural pencil lines.

Perspective

The truly magical feature of drawing is its ability to create an illusion of three dimensions—height, width, and depth—on the two-dimensional surface of a piece of paper. Perspective is a method of depicting objects in the correct scale and relationship to each other. Many of the effects of perspective can be easily observed. For example, we can all see that objects appear smaller the farther away they are. Although perspective effects are less complex in landscapes than in some other genres, it is still important to understand the basic rules if you are to make drawings appear convincingly three-dimensional.

Simple linear perspective

The concept of perspective is based on the optical illusion that receding parallel lines converge, finally meeting at a point, referred to as the vanishing point, on what is known as the horizon line, which is your own eye level. Objects become smaller and smaller toward this horizon line, so that if you had three trees of a similar size placed at different distances from you, the nearest one clearly would be the largest.

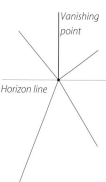

Vanishing point

Horizon line

This tree-lined road is a classic example of linear one-point perspective, where the receding trees meet at a single vanishing point on the horizon line in the lower half of the drawing.

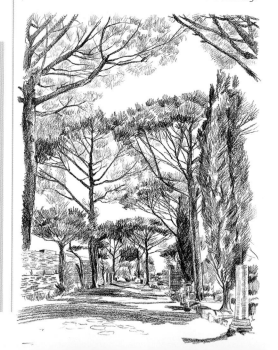

ARTIST'S TIP
Judging the relative sizes of objects at different distances can be difficult at first. It is often hard to appreciate how small, for example, a distant field is, because your knowledge tells you that it is actually the same size as one in the foreground. If you have problems with relative sizes, take measurements by holding a pencil up at arm's length and sliding your thumb up and down it.

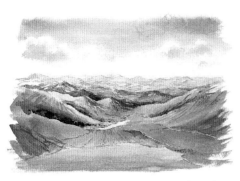

The effects of aerial perspective, which makes colors appear paler and bluer toward the distance, are very clearly seen in an expansive landscape like this mountain view.

Aerial perspective

Far-off objects don't just appear smaller as they recede; they also become less distinct, with little visible detail, paler colors, and reduced contrasts of tone. This is known as aerial, atmospheric, or color perspective, and is the primary means of creating the illusion of space in landscape drawing. Tiny specks of dust in the atmosphere cause colors and tones to become paler in the distance, where objects have very little distinguishable detail. The colors also become "cooler," with more blues, grays, and blue-greens. To take the example of the three trees again, the one in the foreground will show strong contrasts of tone, and warmer, yellower greens; the middleground tree will veer toward blue and be lighter in tone; and the distant tree will be paler and bluer still.

Artistic license

The effects of perspective can be exaggerated to make more dynamic compositions and color schemes. You can bring in warmer colors than you actually see, such as reds and oranges, in the foreground in order to bring it forward in space and push the distant areas farther away. You can increase the width of a road or river in the foreground, artificially narrowing it as it recedes, or you can give extra height to a foreground feature, such as a fence. Artistic devices such as these can make a drawing more exciting by enhancing the sense of depth and the feeling that the viewer can "walk into" the scene portrayed.

Objects become smaller the nearer they are to the horizon line. The diminishing patchwork of vineyards, and the receding road, have been exaggerated slightly in this sketchbook drawing to draw the eye into the distance.

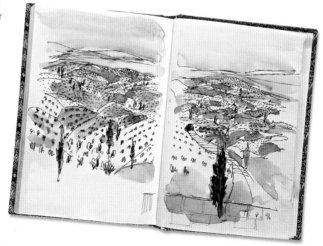

Tutorial **Snowy lane**

Snow is always a beguiling subject, especially when lit by sunshine, because the snow reflects the blue of the sky, creating lovely blue or violet shadows. In this case, the warm browns and yellows of the trees contrast excitingly with the snow shadows to make a simple but attractive color scheme. The artist is working from a photograph that he took as a precaution, knowing the snow was unlikely to last long enough to be drawn. He has made a more lively pattern than that seen in the photo by taking the sunlit patches right across the lane, instead of concentrating most of the shadow in one place.

2 Add raw sienna in the tree trunk area. Color the shadows with a light mixture of Payne's gray and indigo, making sure they follow the drawn lines that describe the shapes of the bank and the ruts in the lane. The color scheme is based on the contrast of cool blues and warm browns and yellows. Try to use the same basic colors in all your mixtures, to unify the composition. When the washes have dried, use carbon pencil to sketch in the tree trunks and fence at the top of the right bank.

1 Start by making a drawing with carbon pencil, sketching in the shadows up the right-hand bank and the main tree masses, but not the tree trunks. Take care with the converging perspective lines of the banks and lane. Then block in the area at the end of the lane with a mid-tone mixture of cobalt blue and indigo, warmed with touches of burnt sienna and raw sienna.

Reference photograph

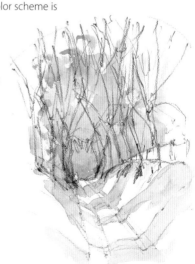

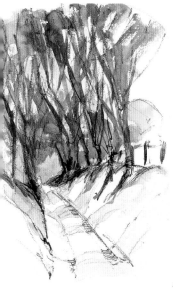

3 Block in the tops of the trees with a mix of burnt umber and raw sienna, with a little ultramarine blue here and there. The brown mixtures laid over the first wash of blue-gray at the end of the lane help the sense of recession. Allow to dry, then reinforce the drawing using carbon pencil.

MATERIALS

- *Watercolor paper*
- *Carbon pencil*
- *Watercolor paints: cobalt blue, indigo, burnt sienna, raw sienna, Payne's gray, burnt umber, ultramarine blue, alizarin crimson*
- *Small round brush*

4 Using a very pale mixture of burnt umber with a touch of alizarin crimson, wash over parts of the lane and banks, taking some of this new color over the blue-gray of the shadows. This warm color makes a link with the trees, tying the two areas together. Add a red-clad figure to create a strong focal point at the end of the lane. When painting a distant figure, avoid detail. Identify the main shape, and try to use no more than one or two dabs of the brush.

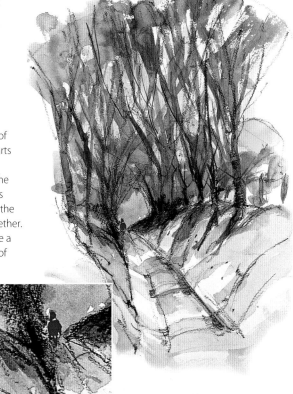

Tutorial **Pumpkin field**

When drawing a landscape, the most significant element is the physical space. In a portrait or still life, the space is quite shallow, sometimes no more than one or two feet, but in a landscape, it may extend as far as the eye can see, and it is important to find ways of conveying this sense of recession. Faraway features in the picture appear less distinct than closer objects, due to aerial perspective. When working with a medium such as colored pencils, you can emphasize this characteristic by drawing loosely in the background, with the more detailed work restricted to the foreground. The artist has omitted the large shed on the right, because it leads the eye out of the composition.

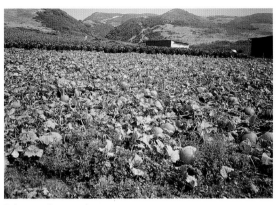

Reference photograph

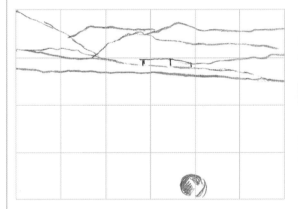

ARTIST'S TIP
It is helpful to mark in the horizon (eye-level) line when you begin to draw, so that you can make the perspective consistent. If you have to change position as you draw, perhaps sitting down if you began standing up, the horizon line will change with you, which can be confusing if you have not clearly established it.

1 This field of pumpkins is very flat, stretching away toward the distant mountains and separated from them by the tall crops in the field beyond. Since there are few other outstanding features, apart from the rather unexciting sheds, the pumpkins will form the main focus of interest. Set the composition on the page, working lightly with a green-gray pencil. Trust in your eye to measure the position of the field edges and the outline of the mountains; this is to be a free sketch, so don't labor the drawing at this stage. Lightly draw in the large shed near the center, using a dull red. Mark the position of the nearest pumpkin, using light orange.

2 Having marked the position of the nearest pumpkin, draw in the farthest one above it, judging its size against the first one. Lightly draw in a grid as a guide for the relative sizes of the pumpkins in each row. Add more pumpkins to the field; sometimes there will be several together, and sometimes there will be gaps. Erase the grid. Mark in the hose reel and little shed below the "V" in the mountains in light blue.

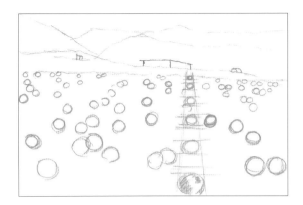

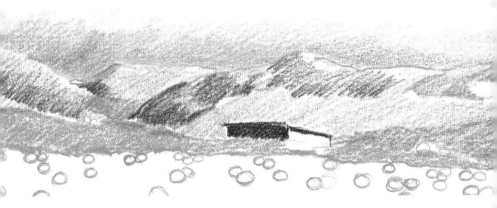

3 With a viridian or blue-green pencil, block in the crop around the shed; this is the darkest part of the picture. Block in the mountains, strengthening the color as you work in layers toward the foreground. Using light blue, work out from the mountains, allowing the sky to fade out to a vague irregular edge. Draw the shadow side of the shed in a deep red, using the same color to underline the shadow on its lit side. The shed forms a subsidiary center of interest that helps to lead the eye in from the field to the mountains.

MATERIALS

- *Drawing paper*
- *Colored pencils: green-gray, dull red, light orange, light blue, viridian or blue-green, light green, yellowish pale green, mid-green, gold-orange, brick red, blue, gray, ocher, brown, red-violet, blue-violet*
- *Plastic eraser*

4 With a light-green pencil, block in color across the far side of the pumpkin field, drawing leaf edges to overlap some of the pumpkins. As you work toward the foreground, the leaf shapes appear larger and more separate, allowing the ground to show through. Use a yellowish pale green to draw the stems. Color the pumpkins, using pale gold-orange as a base overlaid with deeper orange to build the rounded shapes.

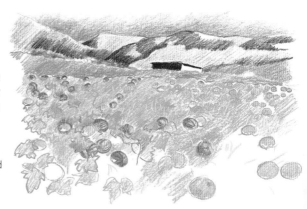

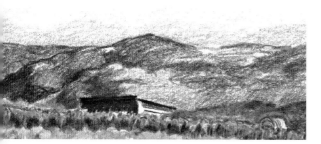

5 Make stippled and dotted strokes in deep greens for the tall crop behind the pumpkin field, then slightly build up the colors of the shed and hose reel with brick red and blue and gray respectively. To suggest the distant forested slopes, make soft, scribbly marks in ochers, greens, and browns.

6 Where the plants are spread apart in the foreground, make some roughly drawn marks to suggest broken soil and then work over these with deep violet in the shadows of the plants. Work over the blocked-in area of pumpkin greenery, breaking it up with deeper greens to give an impression of the massed leaves.

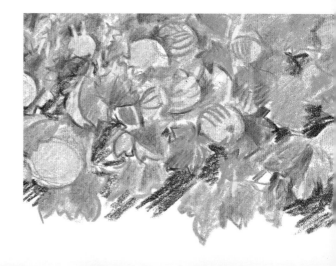

7 Using a blunt pencil, soften and slightly darken the edges of the mountains with deep red-violet, then blend the sky and the farthest mountains a little by working over them with white. Generalizing the "busy" areas of the middleground and background slightly and bringing more color and detail into the large foreground area ensure that space and distance remain important, while the foreground is lively and interesting.

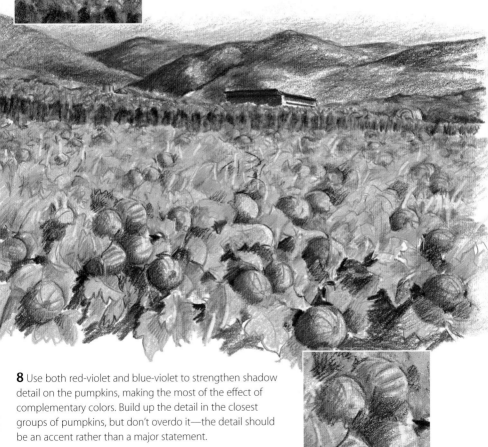

8 Use both red-violet and blue-violet to strengthen shadow detail on the pumpkins, making the most of the effect of complementary colors. Build up the detail in the closest groups of pumpkins, but don't overdo it—the detail should be an accent rather than a major statement.

Tutorial **Rooftops**

Drawing scenes with buildings in them can be intimidating, because the architecture needs to appear accurate. However, if you tackle an apparently more complex subject, such as this view over rooftops, you can focus less on the exact reproduction of the details and structures than on the composition. The artist has altered the skyline by bringing in hills on the right and left, and added people in the foreground. Not only do these provide a narrative touch that builds up a more complete picture, but they are also effective pictorially, strengthening the impression that we are looking out over the scene, just as they are. To achieve the rules of distance, remember the effect of aerial perspective, with buildings of a similar size becoming smaller as they recede in space and also fuzzier in detail, with greatly reduced contrasts of tone. On the skyline, everything is a blurred gray.

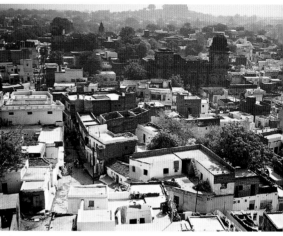

Reference photograph

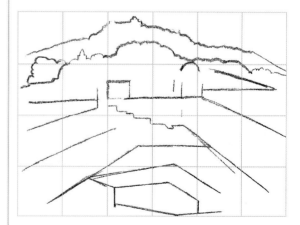

MATERIALS

- *Drawing paper*
- *B pencil*
- *7B pencil*
- *Plastic eraser*

1 Choose a focal point—in this case, the old palace—and pick it out very lightly with a B pencil. Avoid placing it right in the middle of the picture. Once you have done this, you can organize the medley of other buildings. Although they are in reality set at random angles, rationalize them to provide diagonals that lead the eye into the center. Indicate the skyline and distant trees.

2 Clarify some of the main features, such as the dome on the right of the palace, and decide on the outer boundaries of the picture. Take care with the perspective and structure of the tower and dome, because this is the main center of interest and will attract most attention. Add more structural guidelines to some of the foreground buildings.

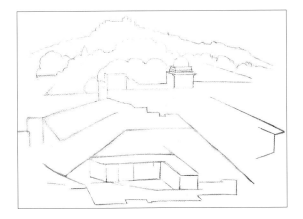

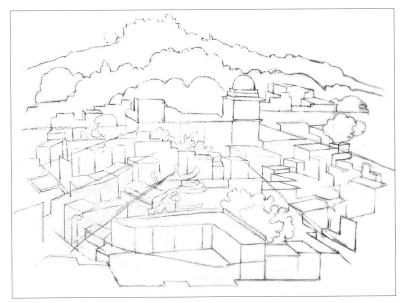

3 Using the basic directional lines, continue to build up the picture by indicating the blocking of individual structures. Be sure to keep the verticals truly vertical; use a ruler if it helps. Contrast the flat-roofed cube shapes of the buildings with the curvilinear outlines of trees so that a satisfying balance is achieved. Look carefully at the trees to analyze their shapes; it is easy to make them all the same.

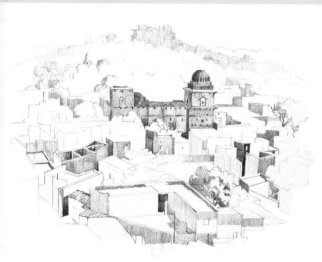

4 Begin to make the drawing look three-dimensional by working in tone. First, erase the directional lines, which have served their purpose, and then use a 7B pencil to add areas of differing tone. Remember the effectiveness of counterchange—dark shapes against light ones. Build up the forms of the trees with shading on the shadowed sides of the foliage clumps—the light is coming from the right.

5 Begin to add detail, suggesting the buildings on the hillside. Strong contrasts of tone draw the eye to the focal point, so leave the trees and building in front of the palace as white paper to contrast with the dark shape behind.

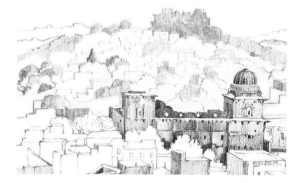

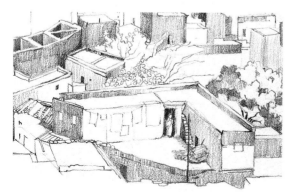

6 Add small areas of dark tone, distributing them to form a balance, and sharpen up the line drawing in the foreground and middleground to bring these areas forward in space. Add more detail to the nearest building: a pile of wood in the courtyard, hanging laundry, and a figure in the doorway, light against dark.

7 Draw in more detail on the palace, giving an indication of the texture within the overall tone. Soften the skyline building, and add touches of pattern and texture throughout the drawing to contrast with the stark cube shapes of the buildings.

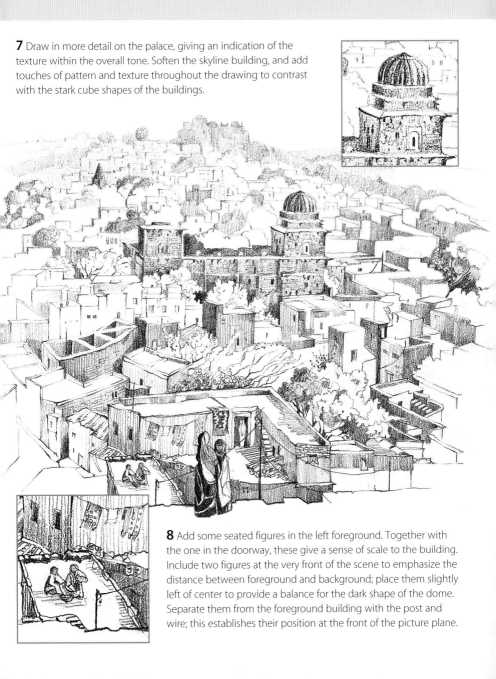

8 Add some seated figures in the left foreground. Together with the one in the doorway, these give a sense of scale to the building. Include two figures at the very front of the scene to emphasize the distance between foreground and background; place them slightly left of center to provide a balance for the dark shape of the dome. Separate them from the foreground building with the post and wire; this establishes their position at the front of the picture plane.

Composition

However well you can draw, your drawings will not succeed unless you think about how to compose them. A picture with a dominant feature placed right in the middle is usually very dull, failing to engage the viewer's attention. Although cropping the design around a center of interest can be effective, don't concentrate all the attention on the focal point, leaving dull areas elsewhere. Always try to create a rhythm in the composition that leads the eye into and around the picture, and create interest by varying shapes and balancing tones.

Preliminary decisions

When you are sketching outdoors, you can move around to choose the best viewpoint, which is the first step in deciding on the composition. Using a viewfinder (a piece of cardboard with a rectangular hole cut in it) is very helpful in making these first decisions, and you can hold it up at different distances from your eye to experiment with different skylines, more sky, or more foreground. If you have time to visit the scene more than once before sketching, choose different times of day, because you may find that a different light source, perhaps with more dramatic shadows, improves the composition.

Experiment with a viewfinder to find the most interesting scene to draw and the best format.

Focus and variety

The focal point in a landscape is usually placed in the middle distance, but avoid putting it right in the center of the picture, and think of ways to lead the eye toward it. This could be the diagonal lines of a foreground field or a path curving in from the foreground. Also, make the contrasts of tone or color strongest at the center of interest, because this automatically draws the eye.

Vary the shapes, contrasting squares or rectangles with round shapes and curves, and don't repeat exactly the same shape in any one area. Distant trees, for example, may appear as little more than rounded blobs, but they are not all uniform. If the composition is mainly horizontal, as in a landscape with fields, putting in a vertical object, such as a tree or fence post, will hold it together.

ARTIST'S TIP
The upright position for a drawing surface is called the portrait format, and the lengthwise position is known as the landscape format. However, the landscape format does not suit all open-air scenes. For example, if high peaks or tall trees seem to be truncated in a landscape format, they may be better in a portrait one. Use a viewfinder to help you decide on the best format as well as the best view to draw.

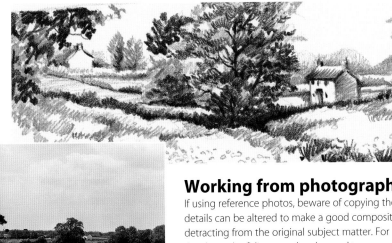

Working from photographs

If using reference photos, beware of copying them exactly; details can be altered to make a good composition without detracting from the original subject matter. For example, the sky or the foliage can be changed to suggest different weather or time of day; you can alter the light source, bringing in shadows and stronger tonal contrasts; and you can omit unhelpful features and emphasize others. Don't automatically stick to the same format either. You might make an upright composition from a horizontal photograph by leaving out dull areas at the sides or by increasing the foreground and sky. Think of the photograph as a starting point for the ultimate aim of making the picture work.

Photographs can be useful reference tools and a starting point for a composition. Rather than copying a scene, use artistic license to make the composition more interesting.

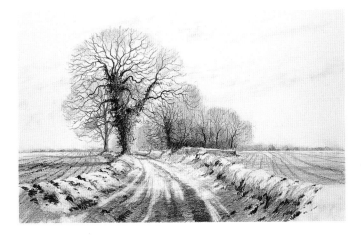

The track in the foreground leads the eye to the large tree just off-center, and then beyond to the next group of trees. These trees hold the composition together.

Tutorial **Waterfall**

When you are working from a photo, there is always a tendency to copy it exactly, using the same composition and putting in every single feature. However, this does not often result in a good drawing. The artist has taken the photo as her starting point, making several rough sketches to figure out the composition. She has decided to crop in a little to emphasize the water and to simplify the rocks, thus giving more emphasis to the waterfall, which is the natural focal point.

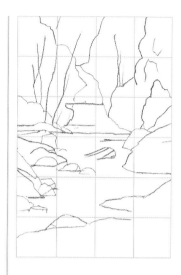

1 Establish the main features using an HB pencil. The waterfall is placed higher in the composition to ensure that it catches attention as the focal point. The water in the foreground has been increased to make a feature of a reflection from the large rock on the right, and the log has been omitted as an unwanted distraction.

MATERIALS

- *Drawing paper*
- *HB pencil*
- *3B pencil*
- *9B pencil*

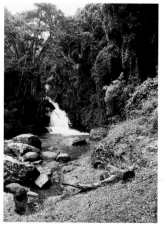

Reference photograph

2 Shade the woodland and rocks on the right, varying the strokes and leaving white paper for the tree trunks and for occasional clumps of foliage. Suggest the foliage against the sky with small marks going in different directions. With short vertical strokes, put in the steps of the waterfall, keeping the top edge soft and varying the bottom edges to suggest foam on the water.

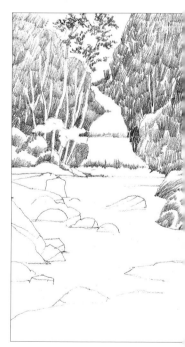

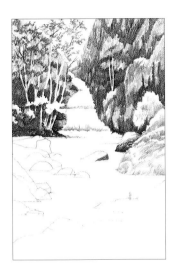

3 Change to a 3B pencil to deepen the tones on the foliage, leaving some of the first tone showing. To suggest recession, make the clumps of foliage smaller toward the background. Once the tones of the trees are in place, you will have a key against which to judge the tones needed for the rocks. Shade the shadowed sides fairly heavily with the 3B pencil.

4 Repeat on the water and rocks the middle and dark tones used for the trees. Use an HB pencil and diagonal strokes for the foreground grass.

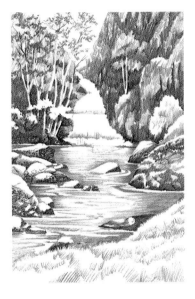

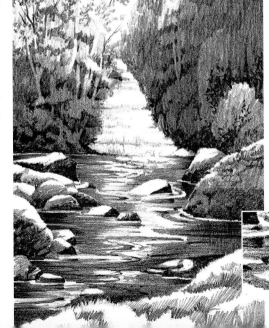

5 Put in some ripples and reflections. Shade the steps of the waterfall with an HB pencil, keeping the tone light so that it reads as a pale shape against the dark trees. Use a 9B pencil to add a strong reflection below the large rock on the right. Use a 3B pencil to put in some dark foliage in the background, then blend it with the HB pencil.

Tutorial **Rustic hill town**

The artist wished to capture the upward sweep of the hillside and the exciting pattern of shapes that form the skyline. To do this, she made more of the right-hand bank, simplifying it so that it forms a series of strong lines leading up to the church tower. Then, to avoid the focal point of the drawing—the tower—from sitting too near the center, she truncated the nave of the church. A few tall trees have been added on the skyline on the left of the town to complement the tower and tall house and stress the vertical emphasis of the composition. Remember that you can refine the composition as you progress by removing unwanted lines with a kneadable eraser.

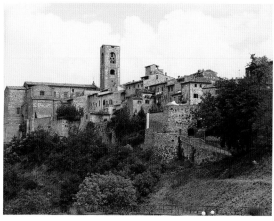

Reference photograph

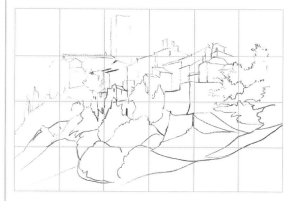

ARTIST'S TIP

The most enjoyable part of any drawing is adding the final details, but try not to overdo things or the drawing could become busy and overworked. It is not always easy to know when a picture is finished, so if you are not sure, put the work away for a while and then come back to it with a fresh eye.

1 Sketch in the main building blocks, paying particular attention to the silhouette of the tower and rooftops and to the upward sweep of the hillside. Work lightly at first, increasing the strength of the line when you are sure of the placing of the main features. Try to bring some rhythm into the composition by contrasting the curves of the trees with the geometric shapes of the buildings. Indicate the occasional roofline and one or two windows and doors to provide a kind of "punctuation mark."

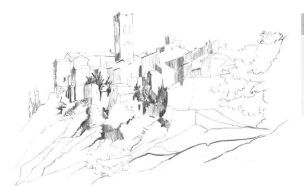

MATERIALS

- *Drawing paper*
- *Sanguine conté pencil*
- *Kneadable eraser*

2 Start adding tone on the key parts of the composition to build up the pattern of light and shade. Work the shaded sides of the buildings with vertical hatching strokes, varying the tones. Emphasize the line in places, treating the foreground in a fairly abstract way, using line to suggest a series of shapes.

3 Leave most of right-hand tree as white paper, making small dark marks at the edge to indicate the foliage. This tone makes the white foreground come forward, pushing the town back in space.

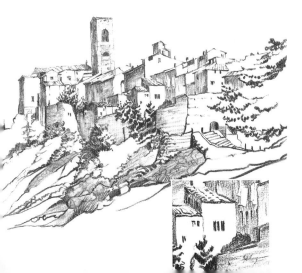

4 Add more shading to build up the forms and contrasts, then turn your attention to the details. The doors, windows, roof tiles, and so on help to give the impression of a real town. Small touches, such as hanging laundry, add human interest, but also play a part in the overall tonal pattern, providing a small area of counterchange—light against dark and dark against light. Shade the middleground in a middle tone to tie in with the buildings.

Tutorial **Pond and hawthorn bush**

It is wise to have your camera with you at all times; you may see a good subject at any point in the day, even when you are simply going shopping or collecting the children from school. This scene, with the hawthorn in full bloom complemented by the buttercups in the field beyond, was one that the artist happened upon by accident, but she felt that it was too good to miss and took several reference photos as well as making a quick sketch. She has made several compositional changes to the final picture, notably increasing the slope of the field, exaggerating the reflection, and simplifying the large right-hand tree so that it forms a more defined shape that contrasts with the hawthorn. The addition of some really dark tones gives structure to the composition.

1 Take a number of reference photographs from different angles, so that you can choose a composition that inspires you. Although the subject is the same, the focal points in these photographs are different. For example, the hawthorn bush is dominant in one, while in another the water takes precedence.

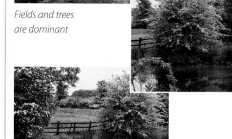

Fields and trees are dominant

More foreground foliage

Water takes precedence

Selected reference photograph

MATERIALS

- *Ocher-colored pastel paper*
- *Pastel pencils: ocher, pale blue, purplish blue, greenish blue, dark green, mid-green, blue green (light and middle tones), yellowish green, creamy yellow, pink (pale and middle tones), dark brown, yellow (middle and deep tones)*

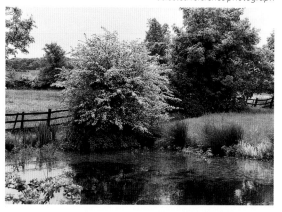

2 The choice of paper color is important, because it will influence the pastel colors laid over it. A light ocher-colored paper will give a warm glow to the work. Draw the main lines of the composition with a pastel pencil just a shade or two darker. Do not use graphite pencil for the drawing, because it is slightly greasy and is difficult to cover with pastel color.

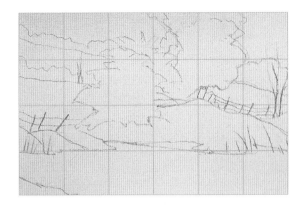

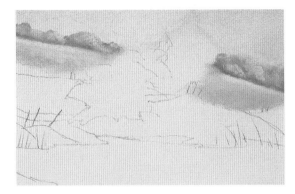

3 Start at the top of the sky, using pale blue and blending it toward the bottom by rubbing with a finger. Lay in the background bushes with a darker, more purplish blue, blend in, and then use the sky color to pick out the light sides. For the distant fields, use a light greenish blue. Reserve the central area as the paper color.

4 With a dark green pastel, lay in the shape of the right-hand tree; use a lighter shade to indicate the highlights on the foliage clumps. Use a mid-tone blue-green for the background tree and hedgerow because they are more distant, again lightening some of the clumps with a paler shade. Paint the middleground fields with two shades of yellowish green, making them darker at the top. Add the dark green of the pond bank.

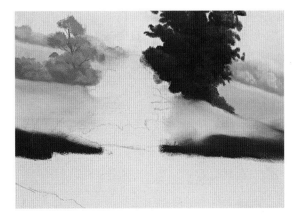

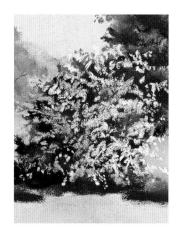

5 Start the hawthorn bush in the same way as the dark tree, but don't cover it with the green. For the blossom, use pale and mid-tone pink on the sunlit side, and pale blue for the shadowed areas, varying the size of the pastel marks to suggest that some areas are coming toward you and others receding. The light is coming from the right, so concentrate the lighter greens on that side. Take some of the sky color into and around the clumps of foliage and put in touches of very light creamy yellow at bottom right to reinforce the sunlit effect.

6 Put in the smaller tree on the right, using the same greens as for the background trees. Leave gaps between the clumps of foliage and run the dark brown branches between them. Add the dark brown fencing, with highlights.

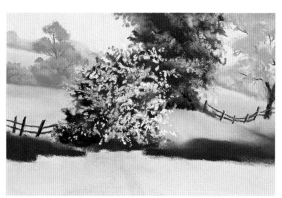

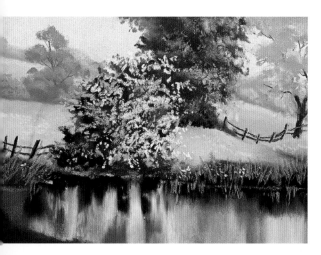

7 The reflections provide strong verticals that lead the eye up to the focal point. Use the same colors for the reflections as for the landscape features, but make vertical strokes, blending the colors with a finger to give a soft effect. Indicate the reeds and grasses on the bank with mid-green, and make a few small flower-shaped blobs with blossom colors. Lay in accents of deep yellow on the side of the tree, and lightly suggest the buttercups in the field with pale yellow.

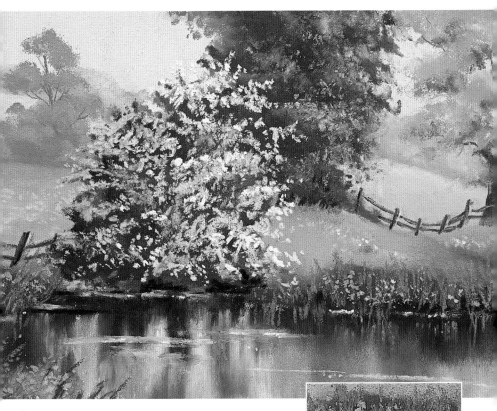

8 Add the final accents and details that will bring the drawing to life, but take care not to overwork it. It is often necessary to exercise a little artistic license when sketching reflections, because these give the impression of a vertical surface rather than a horizontal one. Suggest a few ripples to explain the surface of the water. The bank of flowers to the right of the hawthorn bush needs to come forward, so put in some flowers and foliage, working these bright color accents over the deep green.

Skies and trees

When drawing skies, you don't need to reproduce every cloud in minute detail, but you do want to give an impression of the weather conditions, because this will give atmosphere to the work. Similarly with trees; unless you are really close, you need not engage with botanical detail, but you do want to give an idea of the type of tree. Look for the main shapes and forms first, because these give vital clues to the species and maturity of the tree. An oak tree has a very different profile to that of a conifer or silver birch, and young saplings have a different skeleton from more mature trees.

ARTIST'S TIP

A common mistake is to make all clouds roughly the same size, but remember the laws of perspective. Clouds are much larger directly overhead, because they are nearer to you. Think of the sky as a flattened-out dome, with the rim resting far away on the horizon. There the clouds will appear small and bunched together, with minimal contrasts of tone and color, while those above you may have clearly defined tones and colors.

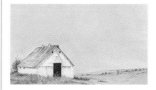

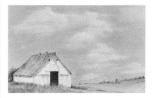

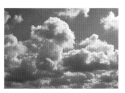

The atmosphere of a drawing without a drawn sky (top) is altered dramatically with the addition of a toned sky (center) and clouds (bottom).

From top to bottom: cumulus, cirrus, and rain clouds.

Skies and clouds

In a monochrome drawing, skies can be left as white paper, but sometimes the sky is as important as the land, so you will need to give a fuller account of it. If you are using any of the color media, you will need to give the sky more thought. A general rule is to avoid detail in the sky if you want to focus attention on the land—for example, in a painting with a high horizon line.

You may like to practice the three basic cloud formations: white fluffy cumulus clouds; whispy cirrus clouds; and stormy rain clouds. Lay an area of tone or wash in the sky, and then lift out the cloud shapes with a cotton ball or tissue. Storm clouds are very effective when painted wet-in-wet, dropping darker colors into a lighter wash, and then lifting out highlights while the paint is still wet.

Trees

As well as the shape, foliage colors are an important factor in helping the viewer to identify trees; they also give you the opportunity to add interest to your drawing. The colors will vary from blue-greens to yellow-greens and from dark to light—and from yellows to oranges and reds in the fall. Even in an area perceived initially just as green, you can interpret the colors, bringing in blues, yellows, and purples. Tree trunks and branches are rarely brown; they can be gray, green, and even red, depending both on the species of tree and on the lighting conditions.

In summer you will only see glimpses of trunks and branches, so it can be difficult to understand their relationship with the foliage, but in winter you can clearly see the structure of trees, so this is the time to observe, draw, and acquire the knowledge that will make your subsequent drawings better and more confident.

Pine Cyprus

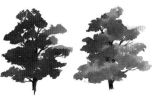

Beech Chestnut

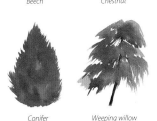

Conifer Weeping willow

Trees grow in a variety of different shapes and colors.

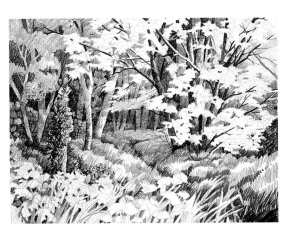

In summer, the full foliage and dappled sunlight on trees and undergrowth camouflage the basic shape of the trunks and branches.

The bare tree branches and flat light of a winter's day make a stark image.

Tutorial **Palm trees**

Traveling to new places presents us with a variety of potential subjects that may be quite overwhelming. However exciting the subject may appear, never lose sight of the purely pictorial values, because an awareness of these will help to simplify decisions about what to draw and what viewpoint to choose. Look for shapes and patterns in the landscape that provide naturally interesting compositions. In this example, the angled palm trees form a number of intersecting triangles that give stability to the composition, balanced by the dynamic sweeping diagonals of the fronds, which impart movement and drama to the picture. Conté crayon is an excellent medium for this kind of drawing, because you can use it on its side to establish blocks of tone rapidly, and make a wide variety of marks with a sharp corner of the point.

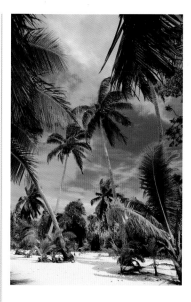

Reference photograph

1 The two main trees form an almost symmetrical triangle, so if you extend the lines to complete the triangle, you will find it easier to judge their angles. Sketching in a light vertical line will help you to get the angles of the trees right, because you can compare the left and right sides. The vertical line also cuts across the eye-level line at the edge of the sand. The low horizon emphasizes the height of the trees and the intensity of the tropical sky. You can erase the guidelines later with a kneadable eraser.

MATERIALS

- *Drawing paper*
- *Sanguine conté crayon*
- *Kneadable eraser*

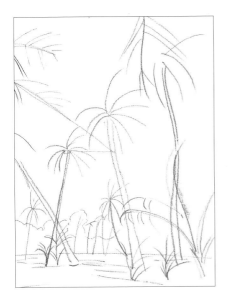

2 Gradually build up the outlines of the trees. The palm trunks will appear more natural if you don't draw perfectly straight lines, and it is easier to create the sweeping curves by drawing them in long strokes, working from the elbow rather than just bending your wrist. Use the main trees to check the proportions and angles of other elements in the picture. The angle of the frond sweeping in from the upper left side can be verified by imagining where the line of the midrib would touch the trunk of the big tree.

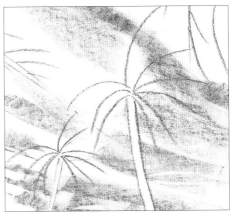

3 Suggest the tone for the sky by using the side of the crayon; then rub over it with your finger to blend and soften it. Don't blend every area of tone, because the contrast between soft and rough marks will add interest and suggest texture. Erase the background tone from the trunks of the trees where they are in sunlight.

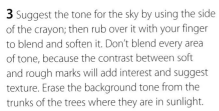

4 Use the side of the crayon to add the shadows on the sand. Don't blend them, so that white specks will show through to give the sand a natural sparkle. Block in the deep shadows between the distant tree trunks with the side of the crayon. Make short, heavy strokes at different angles so that small areas of lighter tone are left to suggest form and texture.

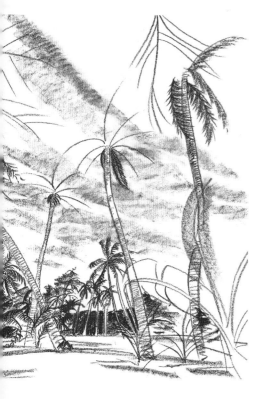

5 To indicate the form and texture of the tree trunks, make short, curving strokes following the cylindrical shapes of the trunks. Leave the areas of brightest highlight white. Start to sketch in the palm fronds, keeping the trees in the background simple; don't try to draw every blade. Some of the dark leaves on the far sides of the tree tops can be used to frame the outline of the trunks. The trees will seem less like flat cutouts if you take the far sides of their trunks into account.

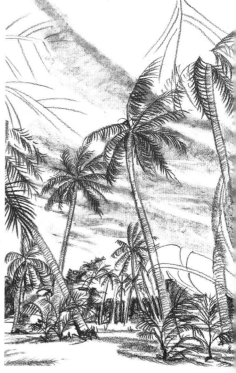

6 Draw the midribs of the fronds using a sharp corner of the stick. Pull it in a curving movement in the direction of growth, away from the tree trunks. Add single blades to the palm fronds in the same way, reducing the pressure as you go. Some fronds will have visible blades on both sides of the midrib, while on others they will both hang down below the rib. Any irregularity in your strokes will make the leaves look more natural and suggest the way that they move in the wind.

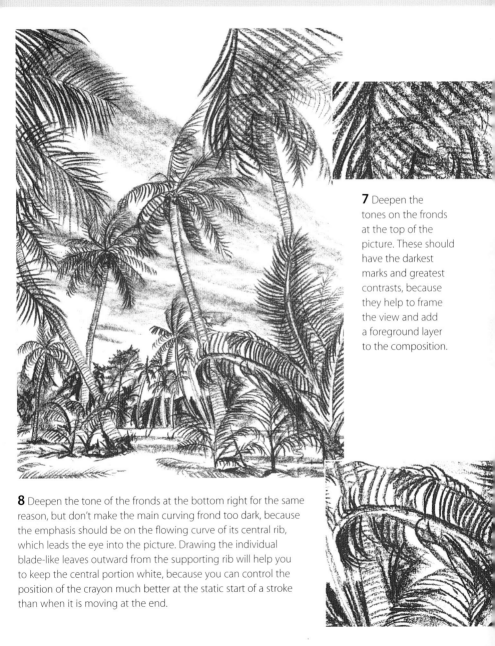

7 Deepen the tones on the fronds at the top of the picture. These should have the darkest marks and greatest contrasts, because they help to frame the view and add a foreground layer to the composition.

8 Deepen the tone of the fronds at the bottom right for the same reason, but don't make the main curving frond too dark, because the emphasis should be on the flowing curve of its central rib, which leads the eye into the picture. Drawing the individual blade-like leaves outward from the supporting rib will help you to keep the central portion white, because you can control the position of the crayon much better at the static start of a stroke than when it is moving at the end.

Tutorial **Trees in a cornfield**

This is a very simple view, and the trees in full leaf make an inviting subject. However, as a composition it lacks structure and drama, so the artist has decided to improve on nature to give the drawing more impact. She has increased the angle of the diagonal bank on the left to lead the eye in toward the curved shapes of the trees, and made the cast shadows a much more positive feature. To give a lively feel to the composition, the theme of diagonals and curves is continued with plow lines crossing over the shadows, and tractor marks crossing over these in turn. She has also pushed the trees back in space so that much of the sky area is cut out. Always consider how you can move features of the landscape around or exaggerate a foreground feature to add interest.

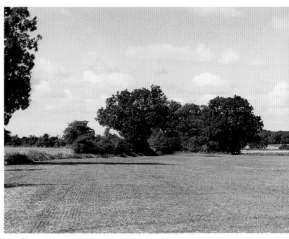

Reference photograph

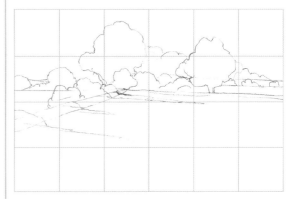

ARTIST'S TIP
Large trees like these are made up from many separate and solid-looking clumps of foliage—a series of small shapes that combine to form the main one. Try to identify the clumps and watch how they are defined by the play of light, but don't lose sight of the main shapes.

1 Draw the trees just as outlines, but take care with the proportions, looking for important clues such as where the smaller tree shapes intersect the larger ones. Always look for the main shapes of the trees first. You may find that it helps to squint your eyes to cut out some of the detail. The cast shadows have been altered in length and direction, creating an interesting pattern that draws the eye toward the diagonal bank of bushes on the left leading toward the main trees. This creates a lively foreground pattern.

2 With an HB pencil, shade in the sky with long strokes, slanting them to add more movement to the composition. Keep it simple to contrast with the complicated tree line. Shade in the distant clumps of trees, again slanting the strokes. Vary the length of strokes to suggest foliage.

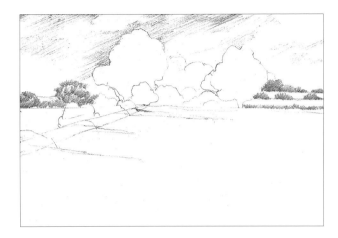

3 Shade in the shadowed sides of the small bushes and the dark areas of the large trees. The light is coming from the left, so the darks will be concentrated on the right side. Leave the trunk of the large right-hand tree as white paper. Simplify the bushes behind the two large trees to throw the sunstruck edges of the trees forward. Pull out the shadows across the field with small diagonal strokes that suggest the grass. Make the strokes smaller toward the distance.

MATERIALS

- *Drawing paper*
- *HB pencil*
- *3B pencil*
- *9B pencil*

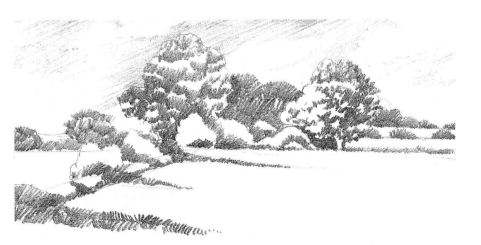

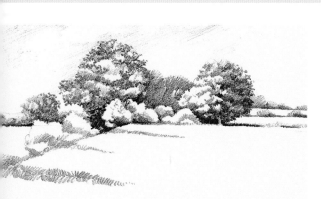

4 Use a 3B pencil to add form and texture to the large trees, making short stabbing strokes at the top, especially on the left-hand tree. Add a middle tone to the small bushes, leaving the tops as white paper. Keeping the direction of the light in mind, shade the dark sides of the background bushes. Emphasize the deep shadows at the base of the trees with a 9B pencil.

5 Lightly draw in the rows of stubble, starting at the back and widening the lines toward the foreground. Draw the tractor lines with small near-vertical strokes, fading out gradually at the center of the field. Use diagonal strokes to shade in the distant field on the left, thus ensuring that the eye is taken in toward the trees. With a 9B pencil, put in dark tones on the shrubs along the diagonal bank; follow the contours of the bank and carry them out into the stubble field.

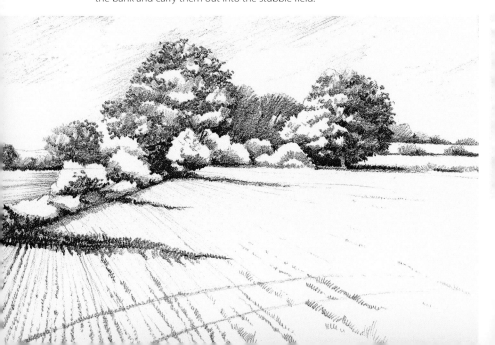

6 Reduce the tonal contrast slightly in the center of each of the two large trees by hatching in a middle tone with an HB pencil.

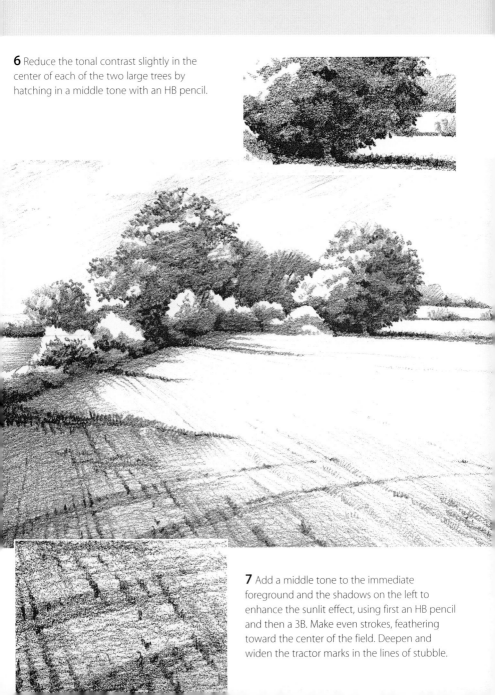

7 Add a middle tone to the immediate foreground and the shadows on the left to enhance the sunlit effect, using first an HB pencil and then a 3B. Make even strokes, feathering toward the center of the field. Deepen and widen the tractor marks in the lines of stubble.

Tutorial **Trees and gate**

Drawing trees in winter or early spring teaches you to observe their different skeleton shapes. This is good practice for drawing a tree in full leaf, because you will understand its underlying structure. Without their leafy cladding, trees offer certain challenges to the artist. Study the branches carefully, noting their thickness, how they grow from the trunk, and the ways in which they can twist downward or back on themselves. To prevent this very symmetrical composition from becoming too static, the viewpoint incorporates elements at different angles, such as the gate and the slope of the foreground. These lead the viewer toward the center and give movement to the picture. The shading is built up with directional hatching of different colors. This helps to create movement and encourages the eye to move around the scene.

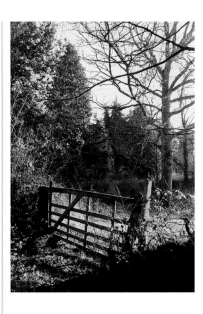

Reference photograph

ARTIST'S TIP

Take special care drawing the branches. One common mistake is to draw them too thick toward the outer edges, when in reality they taper quite sharply to become tiny twigs.

1 Use a 3B or 4B pencil to sketch the outline of the main branches and the gate. It is particularly useful to employ a grid when positioning prominent elements that are at an angle, because these are easy to misjudge. Pay attention to the negative shapes and to achieving consistency in the thickness of each item. Carefully observing the negative spaces will help to confirm that you are creating the correct positive shapes.

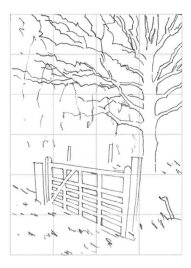

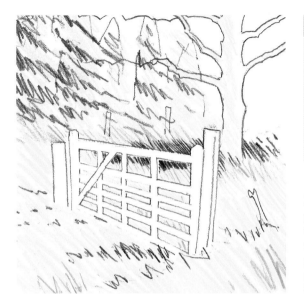

MATERIALS

- *Drawing paper*
- *3B or 4B pencil*
- *Colored pencils: lemon yellow, crimson, cobalt blue, burnt sienna, black, emerald green, indigo*

2 Add diagonal strokes of lemon yellow to give a sunlit effect. This will also add warmth, life, and variation to any color subsequently penciled over it. Add strokes of crimson to the trees, and cobalt blue and black over the grass.

3 Build up cool woodland tones on the grass and fir trees in the background by adding a loose weave of burnt sienna and cobalt blue pencil lines. Leave plenty of white as well. Start to color the gate lemon yellow and define its shadows with black.

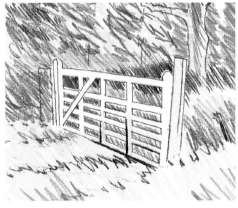

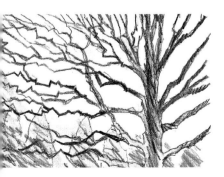

4 Build up the black outlines of the branches, creating interesting shapes and negative spaces.

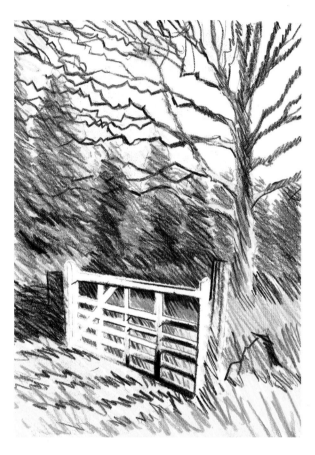

5 Strengthen the main tree with short, loose diagonal strokes of burnt sienna and black. Leave a few glimpses of yellow to give sparkle to the tree. Add crimson and emerald green to the fir trees in the background. Allow vibrant flashes of white paper to show through here and there.

6 Continue to build up the woodland tones on the grass using loose hatches of burnt sienna, cobalt blue, and emerald green. To ensure a strong outline to the gate, pencil the background woodland tones on either side of it up against a piece of cardstock. The cardstock acts as a stencil or mask for the gate. Carefully build up the gaps in the gate with burnt sienna and emerald green. Add black to the gate and accentuate the shadows on the grass.

ARTIST'S TIP

Working with colored pencils allows you to achieve both rich and subtle colors by building up semitransparent layers of different colors. However, make sure you do not press too hard with the pencils or block in areas too solidly, because you risk saturating the paper surface so that it will not be able to accept any further blends of color.

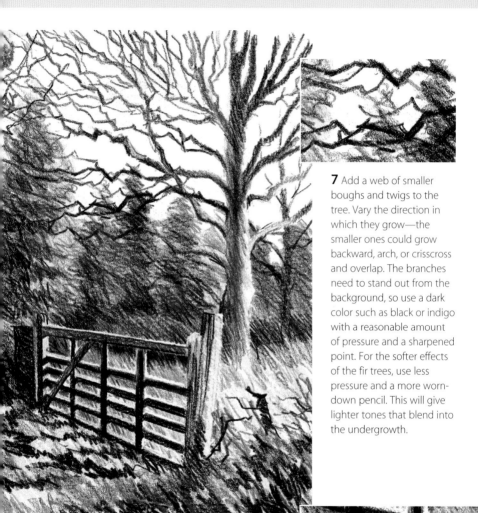

7 Add a web of smaller boughs and twigs to the tree. Vary the direction in which they grow—the smaller ones could grow backward, arch, or crisscross and overlap. The branches need to stand out from the background, so use a dark color such as black or indigo with a reasonable amount of pressure and a sharpened point. For the softer effects of the fir trees, use less pressure and a more worn-down pencil. This will give lighter tones that blend into the undergrowth.

8 The contrast of the dark shadows and white highlights on the gate make this the initial focal point of the drawing. The eye is then led upward from the right side of the gate to the tree. Incorporate areas of shadow into the foreground by hatching black back and forth with a rounded pencil.

Shadows and reflections

Shadows and reflections can play a major part in the composition of a landscape drawing and in its color scheme. Reflections, of course, will only be seen if there is an area of water in the subject, and even small reflections in puddles can be used to add interest and atmosphere. Shadows also help to explain the lay of the land, so make sure they follow the contours rather than flattening them out. If you are working on the spot, the shadows and reflections will change as the sun moves, so sketch in these shapes at the start, and avoid trying to change the picture later.

The sunlight that falls on this tree from the right casts a long gray-tinted shadow across the grass.

The colors in this scene have been exaggerated, with mauve in the shadows to contrast with the yellows.

Shadows

The colors as well as the location of shadows alter according to the time of day, so either sketch them in at an early stage or make notes about the colors so that you can make them consistent. You don't want to have some parts of the drawing with morning shadows and others with afternoon shadows.

The colors of shadows are influenced both by the color of the ground on which they are cast and by the light source. Shadows on snow, for example, are often quite a strong blue, because the white surface reflects the sky. Those on grass will reflect the sky to a lesser extent so that you will see both blues and greens, with the overall color usually cooler than in the sunlit areas. Shadow colors can be exaggerated to give extra punch to a drawing: you can bring in more blues and mauves, add a touch of warm color to a cool shadow, and vice versa.

Still reflections

A still surface of water viewed from a distance produces an exact mirror image of the landscape features above, but if you copy this effect too faithfully, you will lose the horizontal surface of the water. Mute the colors or blur the lines slightly, and consider introducing one or two ripples, or perhaps some floating leaves, to suggest the water surface. When a reflection is closer to you, you will also see some of the colors of the mud or sand beneath the water, so if you are painting the reflection of a boat or rock, incorporate this color into the reflection.

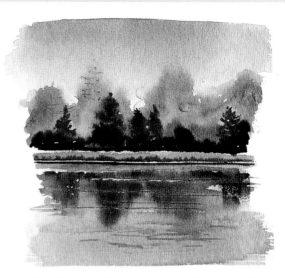

Use a little artistic license to blur the surface of very still water, even if the surface is a mirror image in reality.

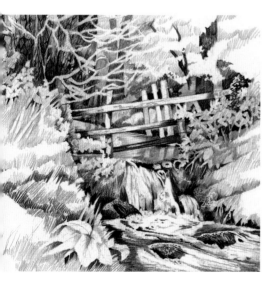

The reflective surfaces of moving water sparkle and scatter reflections in an unpredictable way.

Broken reflections

When the water surface is broken into ripples or wavelets, there will be many small reflective surfaces lying at different angles, so the reflections will be scattered in unpredictable ways. These broken reflections create exciting effects, but they do require careful observation and a degree of simplification. Try to give an impression rather than a literal account, using broken marks or brushstrokes and varying the edges from soft to hard. If you are working from a photo, beware of trying to re-create every ripple and every nuance of light and shade. Too much fussy detail will sacrifice the sense of movement that is all-important in such a subject.

Tutorial **Sunset over water**

There can be few people who are not excited by the glowing colors of sunsets and the way they can transform an ordinary landscape into something new and magical. However, sunsets do present a challenge to the artist, not only because the effects seldom last long enough to sketch on the spot, but also because it is all too easy to sentimentalize them and produce a rather clichéd drawing. The artist has avoided the latter pitfall by using energetic and expressive pastel marks rather than blending the colors by rubbing them into one another, giving the drawing a lively sense of immediacy and movement. He has also worked on watercolor paper, which has sufficient texture to break up the strokes, leaving little specks of white that make the colors sparkle. The composition is unified by the use of color "echoes," with touches of the orange sky color added to the land.

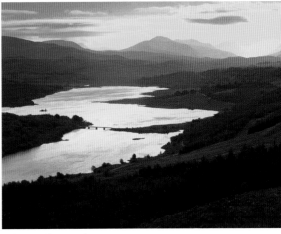

Reference photograph

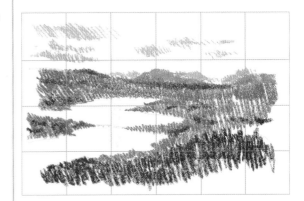

MATERIALS

- *Watercolor paper*
- *2B pencil*
- *Pastels: olive green (middle and dark tones), red, orange, lemon yellow, yellow (light and middle tones), indigo*

1 Sketch the shapes very lightly in pencil, then block in the land using two shades of olive green. Make diagonal hatching strokes, varying the angles slightly. Keep the strokes open and relatively light. Establishing the dark greens provides a key against which to judge the colors for the sky and distant hills. Block in a fairly solid orange for the hill, and repeat the same color in the sky, using lighter, more open strokes. Use a really strong red on the horizon line, bringing a little of it down into the green to tie the two areas together.

2 Color the sky and lake with lemon yellow and touches of orange, leaving the paper white for the sun and its reflection. Take some of the yellow down over the hills so that they blend together slightly. Make a light suggestion of clouds with short strokes of orange and bring in orange at the top of the sky. Describe the flat surface of the lake with horizontal strokes, using two shades of yellow. Darken the foreground with indigo.

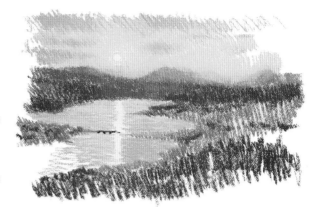

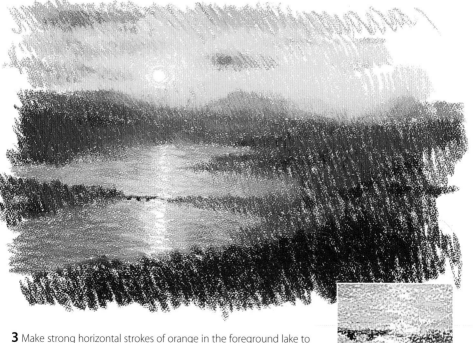

3 Make strong horizontal strokes of orange in the foreground lake to echo the clouds. Add strokes of orange among the greens to ease the transition from middleground to background. Build up the foreground with more indigo, laid on fairly heavily, to push the hills back in space.

Tutorial **Reflections in still water**

A tranquil scene like this invites a delicate watercolor treatment, with soft blends and a harmonious color scheme consisting mainly of blues, yellows, and greens. The artist has played down the patches of bright red in the photo, because these would introduce a jarring note, and has merely suggested the flowers, keeping the colors muted. The artist has also altered the right-hand reeds as a balance and brought them farther into the drawing to lead the eye in. When working in watercolor, always mix up the washes you will need for each stage in advance, so that you don't run out in the middle of a wash. Masking fluid is used here to create pale leaves, allowing the artist to achieve an almost drawn quality in the highlighted details.

Reference photograph

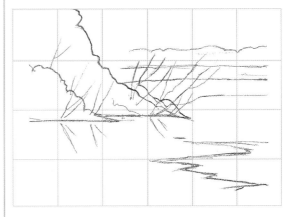

1 Make a simple outline drawing using an HB pencil. Draw the line of the far bank in first, moving it up the page to allow a slightly wider gap between it and the trees on the left. There is no need to sketch the background foliage—a few lines to show where the rows lie will suffice at this stage. Don't try to sketch the foreground trees in any detail; use simple lines as a guide to indicate where they will be.

MATERIALS

- *Watercolor paper*
- *HB pencil*
- *Watercolor paints: cobalt blue, cadmium yellow, viridian, burnt umber, indigo, rose madder*
- *Masking fluid*
- *Long-script liner brush*
- *Small to medium round brush*
- *Knife*

2 Dampen the paper down to the shoreline, taking the brush over the paper twice to make it evenly damp. Apply a wash of cobalt blue to the background trees, then paint a wash of cadmium yellow over the shoreline and the trees on the left. Drop some mid-green (cadmium yellow and viridian) into the yellow wash. Add a broken line of dark color (viridian and burnt umber) along the edge of the lake. The paint will dry with a linear edge where it meets dry paper and a soft one above, where it runs into the other colors.

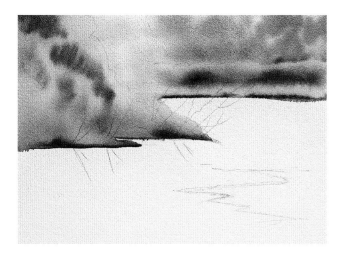

3 Mask out areas of lighter foliage where the left-hand trees cross in front of the background trees. Allow to dry, then dampen the background again, going over the masking. Draw in small strokes of mid-blue (cobalt blue and indigo). As you work forward to the hedge, use darker indigo and define the shore with the same color. Drop in a few patches of rose madder, then allow to dry.

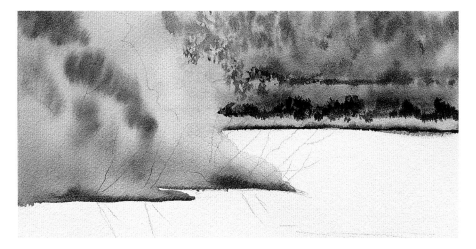

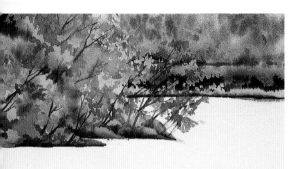

4 Remove the masking fluid by rubbing gently with a finger. Because the fluid was laid over the first yellow wash with darker colors laid on top, the leaves stand out as pale yellow shapes. Paint more foliage, darkening the tones toward the water. Use a long-script liner brush and a mixture of indigo and rose madder to draw the branches running through the foliage. To give a hint of the red flowers among the foliage, paint over the yellow with diluted cobalt blue, then drop in a little rose madder.

5 When the foliage is completely dry, dampen the area of the lake, leaving a little strip of dry paper beneath the left-hand foliage and a larger strip at the far bank. Paint the water with horizontal strokes, starting with cobalt blue and darkening with a cobalt blue and indigo mixture as you come forward. While damp, paint

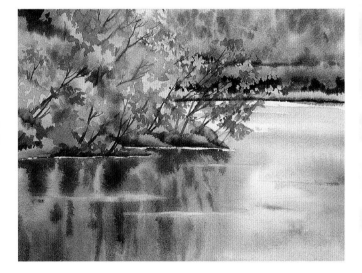

in the reflections of the trees, including a stroke of rose madder flanked by viridian to create a strong passage of color in the foreground. Use a clean, damp brush to lift out a couple of horizontal ripples to break up the reflection and add a blush of green on the right for the reeds.

6 To make the left-hand trees show up more strongly, deepen behind them with a mixture of cobalt blue and a touch of indigo, then brighten them with a touch of yellow.

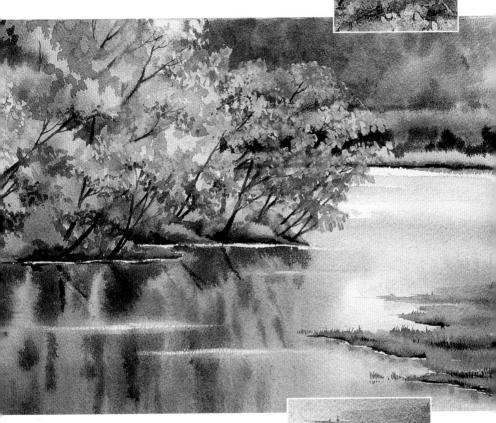

7 Paint the right-hand reeds using the same greens as for the trees. While damp, put in a strong dark at the bottom. Dampen the water area beneath the reeds and drop in the reflection. Let the washes dry and then draw in some green blades of grass with the tip of the brush. Scrape out a few highlights in the water with a knife to accentuate the horizontal surface.

The urban landscape

The urban landscape provides the artist with a wealth of stimulating material. Architectural subjects make simple, almost abstract compositions. Look, for example, at the smooth lines and flat surfaces of modern skyscrapers. In the city you will find exciting arrangements of pattern and tone, and color as intricate as anything to be found in nature. Although architectural subjects can seem daunting at first, they are actually a good deal less complex than many others. Mainly, you will be dealing with simple geometric shapes, mostly rectangles of varying sizes and proportions. Look for these shapes and see how they relate to each other, just as you would when drawing a rural landscape. Don't be overwhelmed by the incredible amount of detail in urban scenes—simplify and edit your compositions.

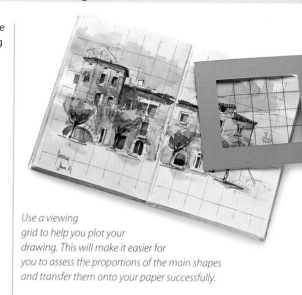

Use a viewing grid to help you plot your drawing. This will make it easier for you to assess the proportions of the main shapes and transfer them onto your paper successfully.

Measurements

Initially, the most important aspect of drawing buildings is getting the proportions right. Look for the main shape first, and ask yourself whether it is more or less square, or forms a tall rectangle with a height considerably greater than its width. You can then check the exact proportions by measuring them. Measure the width by holding your pencil at arm's length and sliding your thumb along it. Then turn the pencil upright and see how many of these measurements fit into the vertical. You can check the proportions of windows and doors in the same way, and don't forget the spaces between them, which are just as important. With practice, measuring becomes a natural part of the drawing process.

To measure objects, hold a pencil at arm's length and slide your thumb up and down the pencil. To measure the angle of lines, angle the pencil until it coincides with the line you wish to draw. Take the pencil carefully down to the paper at the same angle and draw the line.

Multiple-point perspective

The basic rules of simple linear (one-point) and aerial perspective apply to drawings of urban landscapes just as they do to rural scenes (see pages 78–79). However, the multitude of geometric shapes and angles found in the urban landscape often require more complex perspective effects.

When looking at a building from an angle, you will see two walls, and each will have its own vanishing point. This is known as two-point perspective. Each set of parallel lines—those on the left and right—will meet at a point on the left and right respectively, but both will still be on the same horizon line. The nearer the house is to you, the more acute will be the slope of the parallel lines; if the building is in the distance, the perspective effect will be less pronounced.

Sometimes you will find that the vanishing points are outside the edges of your drawing, so you will have to imagine them, but it is always helpful to mark in the horizon line so that you can plot one or two of the more important receding lines. In cases where buildings are set at odd angles to one another, or where bends in a road alter the angles, there may be several vanishing points, but once you have grasped the basic principles, you should be able to figure these out quite easily.

To draw angled lines accurately, hold up a pencil and angle it with the line, then take it down to the paper at that angle and draw the line.

Drawing the reflection of a vertical structure such as a building presents no problems, but note how the more rough the surface of the water, the more scattered and unpredictable the reflection.

The walls of this building become smaller the farther they are from the viewer, like a cube.

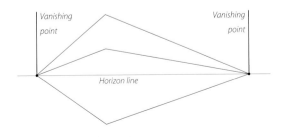

Vanishing point

Vanishing point

Horizon line

Tutorial **Harbor skyline**

A monochrome treatment with strong tonal contrasts is ideal for this dramatic view in which the juxtaposition of simple shapes is the most powerful element. A ballpoint pen can produce more solid darks than a pencil, as well as a wide variety of different marks. The disadvantage is that it cannot be erased, which may make it seem rather intimidating, but the immediacy and freshness of first-time drawing makes for a lively result. Once you have mastered the technique of taking measurements, you should be able to place your marks quite accurately, and deciding how to frame the drawing will enable you to make an exciting composition. Here, the artist has been selective, omitting the catamaran and concentrating on the buildings to the left of it, comprising a dynamic mix of rectangular skyscrapers and the dramatic curved roofs of the Sydney Opera House.

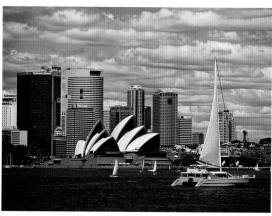

Reference photograph

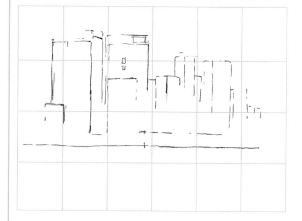

1 Lightly draw in the waterline as a baseline for the buildings. This line measures the width of the finished drawing, and from it you can plot all the points that will define the drawing. Measure the middle of the baseline, and use this to plot the position of the right-hand side of the skyscraper just above the left-hand stack of the Opera House roofs. Plot the rest of the drawing outward from the center, measuring as you go. Start by placing small dots, and then join them up with lightly drawn lines.

MATERIALS

• *Drawing paper*
• *Ballpoint pen*

2 Continue building up the outlines. Take care to place the Opera House accurately, because its curves and light tone make it the focal point of the composition. Notice that the roofs of the right-hand block of the Opera House are slightly taller. Check that the apex of each roof aligns with the verticals of the skyscraper behind it. You can now introduce some of the less rigidly defined features, such as the trees and promenades above the waterline. Echo the shapes of the Opera House with some strategically placed sailboats.

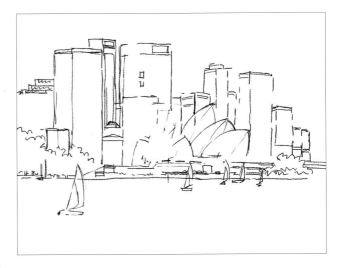

3 Notice the different arrangements of windows in the towers; in some cases the emphasis is horizontal, while others are more vertically striped, or form a checkerboard pattern. Use light pen strokes to establish the pattern grids. The marks can be strengthened when the sketch is more developed. Notice how the light falls from the left, and the shadows cast by the buildings help to clarify their shapes.

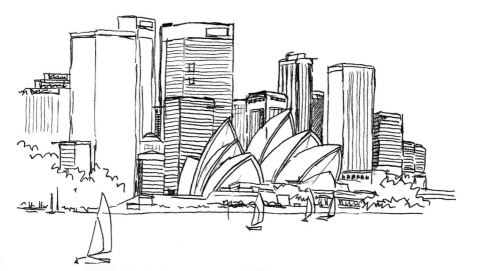

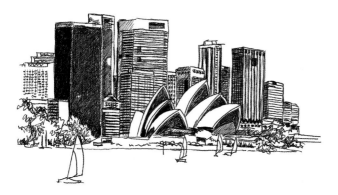

4 Darken the window patterns on the shaded side of the buildings. By working up the large, dark area of glass on the left-hand skyscraper gradually from very light to very dark, you can grade the tones smoothly to show the planes of its walls. Deep shadow in front of each curved roof of the Opera House throws its shape into heavy relief. These lines can be curved to follow the shapes. Use a more scribbly line for the trees. Their loose shapes and uneven texture complement the hard, smooth buildings.

5 Build up a range of tones on the water. The water can be more loosely drawn, but take care to maintain an overall horizontal surface. Vary the weight of marks as appropriate. The water appears darker near the building line, because it is farther away and the ripples cannot be seen. In the foreground, the ripple effect is obvious, so the lines should be opened out. Strengthen the shadow details for a little more contrast and break up the uniformity of the promenades with some light, scribbly texture.

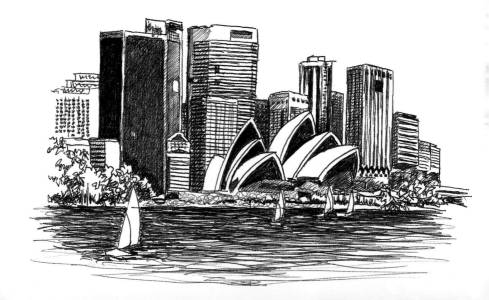

6 Use light stippled marks combined with very light hatching strokes to draw the shadows below the clouds and the sky between them. Notice the almost regular formation of the clouds and their shadows.

7 Make any final adjustments to the shadows on the skyscrapers and deepen the shade beneath the Opera House roofs to as near black as you can get. Although this is a drawing of a very solid subject, its strong shapes are balanced by a range of different weights and textures of marks.

Tutorial **Cityscape**

This view of modern block buildings and skyscrapers has great potential, allowing the artist to exploit the semi-abstract pictorial values provided by the interplay of strong geometric shapes. The reflections, which echo the shapes of the buildings, allow the dominant verticals to be taken right down to the bottom of the picture, and the artist makes the most of this opportunity by exaggerating them slightly, and playing down the shapes of the central boats. He also departs from strict reality in his choice of colors, bringing in complementary colors such as red and green to give the picture extra sparkle. Colors are also repeated from one area of the picture to another to create unity. The drawing is done on watercolor paper, which has enough texture to break up the strokes of the pastel pencils, giving an attractive texture to the drawing.

Reference photograph

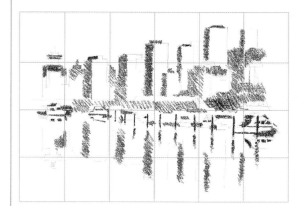

MATERIALS

- *Watercolor paper*
- *2B pencil*
- *Pastel pencils: indigo, dark blue-gray, ultramarine blue, yellow, ocher, bluish green, red-brown, mauve, white*

1 Start with a light pencil drawing, then shade the sides of the buildings with diagonal hatching strokes of indigo and dark blue-gray, varying the tones by increasing or decreasing the pressure. Draw in the boats on the left and right sides of the picture with indigo; those in the center are to be left as light suggestions rather than treated in detail. Mark in the masts and their reflections with indigo. Use dark blue-gray for the reflections of the buildings, positioning them directly below the buildings themselves.

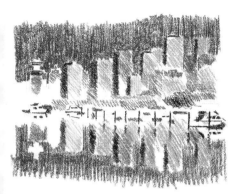

2 Block in the sky and water with vertical hatching strokes of ultramarine blue. Use yellows and ochers for some buildings to ensure that they sing out against the sky. Use bluish green and red-brown for others to introduce a complementary contrast. Take the colors of the buildings down into the reflections, using diagonal hatching lines.

3 Continue adding color, using mauve for the boats and their reflections. Use darker tones of the building colors, plus dark blue in places, to draw horizontal and vertical lines representing spaces between windows and floors. Use vertical lines only in the reflections, letting them fade at the bottom. Add touches of vivid color to suggest the bright lights within the buildings.

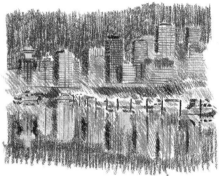

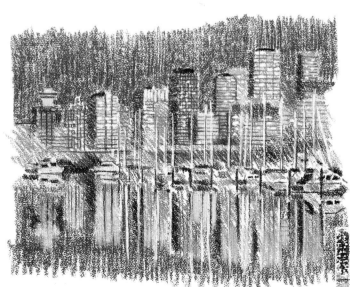

4 Make a few more dark horizontal lines to suggest the boats. Draw the masts with white pencil and darken the areas behind them to make them stand out. Blur the bottoms of the reflections by drawing over them with white pencil.

Tutorial **Reflections in a canal**

Venice is a paradise for the artist and has been for centuries. Tourists are drawn to the major attractions, such as St. Mark's Square and the marvelous view of San Giorgio and the Salute across the Grand Canal, but the quieter squares and lesser known canals provide equally fascinating subjects for the artist and may even enable you to set up an easel without the danger of being trampled by tourists. The view chosen here is one such example. The scene provides a built-in color scheme based on the contrast of blue and yellow, which are nearly complementary, so make the most of this and try to limit the range of colors to give unity to the picture. Remember to look for small decorative touches, like the balconies and shutters, that will give an extra sparkle to the picture and enhance the "sense of place."

Reference photograph

MATERIALS

- *Watercolor paper*
- *Carbon pencil*
- *Watercolor paints: ultramarine blue, raw sienna, sepia, alizarin brown madder, viridian*
- *Fine-nibbed art pen*
- *Black water-soluble ink*
- *Small round brush*

1 Sketch in the rough outlines with a carbon pencil. Carbon pencil makes a darker, heavier line than graphite pencil, but this does not matter, because part of the drawing is intended to show through the paint. Check the angles carefully and make sure the verticals are truly vertical. You can measure from the edges of the paper if you have any doubts. Draw in the main lines of the reflections.

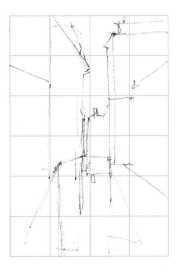

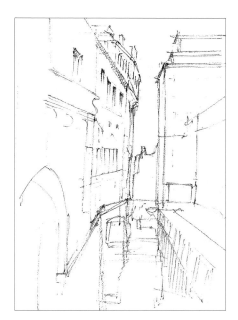

2 Add the main architectural features such as windows, balconies, roof overhangs, and chimneys. Check angles and proportion carefully as you go. Note that the line of buildings turns a corner at the end of the left-hand edge, so that the angle slopes down more sharply on the right. Establish the shape of the barge, which is to be left mainly as white paper.

3 Add the final details, then begin to add color. Paint the sky with a wash of ultramarine blue, grading the wash so that it is darker at the top of the sky and the bottom of the water. The drawing shows through the pale wash, so this area will need little or no extra definition. Let the sky wash dry and then lay a wash of raw sienna over the buildings, leaving the balcony, arch, and area at the top left white for the time being.

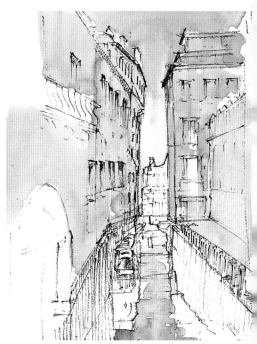

4 It is not always easy to know how to treat shadows, because they can easily become too dark and muddy. Remember that the color of the surface will influence cast shadows. The artist has decided to paint the shadows in two stages, laying one color over the other. Notice that the color changes according to whether it was laid on white paper or over the original raw sienna. Mixing colors on the paper in this way often provides more exciting effects than pre-mixing in the palette.

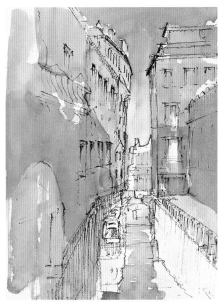

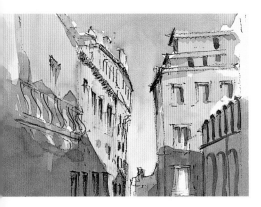

5 Lay a pinkish brown wash (alizarin brown madder or a mixture of colors) over the shadowed areas.

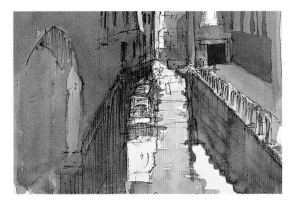

6 The shadows reflected in the water are cooler in color, because they are influenced by the sky color, so use a mixture of sepia and ultramarine blue for these. Repeat this color on the right-hand building to tie these two areas together.

7 Paint the shutters with viridian, then paint a shadow at the left side of the arch and add a little more drawing on the right side to define the shape. Use the carbon pencil again to draw more detail on the balcony. Make a few light pen lines in places to give variety to the drawing, but don't overdo these and avoid making them too precise.

8 Build up the tonal contrast by darkening some of the reflections, using the same mixtures as before. Take small brushstrokes of the dark color out into the water to suggest the slightly rippled surface. Make the color quite strong where the tops of the buildings are reflected, but break up the reflections by using separate brushstrokes and leaving small patches of white paper.

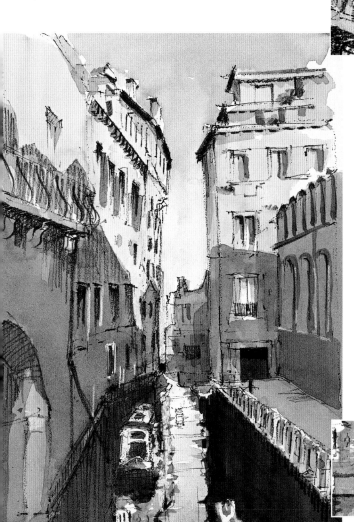

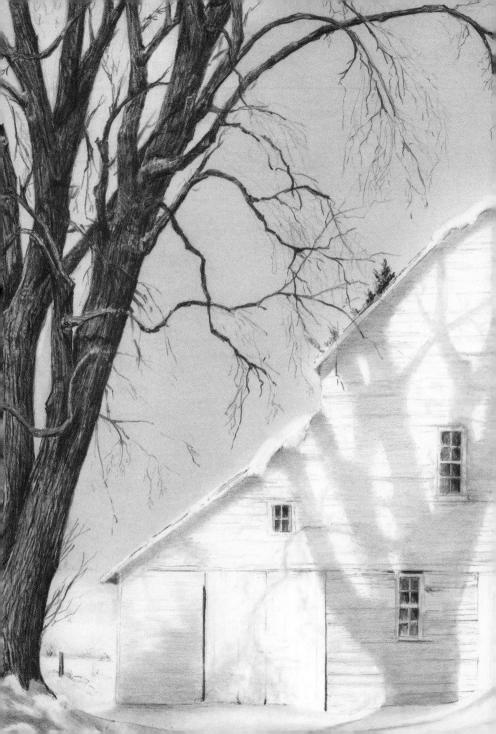

3
Gallery

Inspirational landscape sketches and drawings in a variety of media

Coastlines and cliffs

▼ **Alan Oliver**
Hunstanton Beach
*Charcoal allows you to build up broad areas of
tone more rapidly than pencil, and here the artist
has used blending methods for the clouds and
parts of the foreground, overlaying the blends with
a variety of marks made with the point of the stick.
Highlights are reserved as the paper color.*

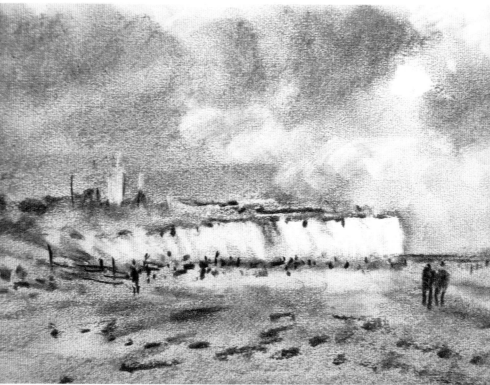

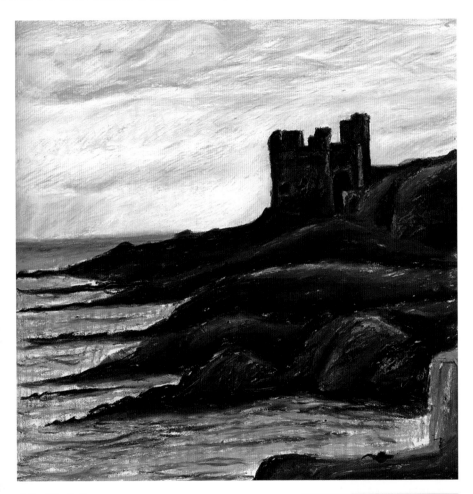

▲ **Paul Bartlett**

St. Maws, Cornwall

Oil pastel is an ideal medium for location work, and in this small sketchbook study, the artist has been able to record the rapidly fading evening light quickly but accurately. He has used the sticks on their sides to block in the dark areas, but treated the sky and sea with lively linear strokes.

Mountains

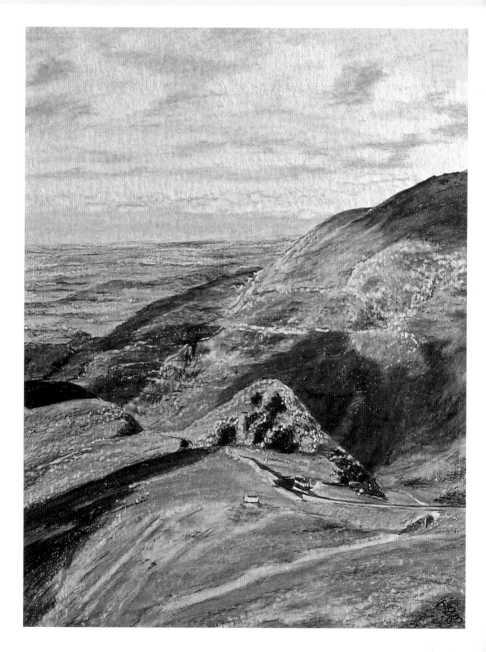

◄ Joan Batty
Snowdon Steam
The softest colored pencils, which give an almost pastel-like effect, have been used for this lovely drawing. Notice how the artist draws the eye to the center of interest through the strong line of the track leading from foreground to middle distance.

▼ Gary Michael
Heart of the Rockies
The strong tonal contrasts inherent in such a scene have been exploited with a soft graphite stick, with marks following different directions to give the composition a lively sense of movement.

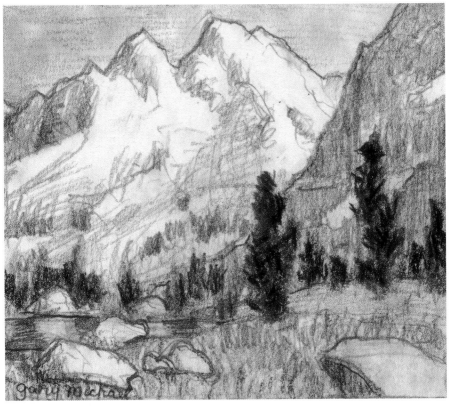

Rocks and waterfalls

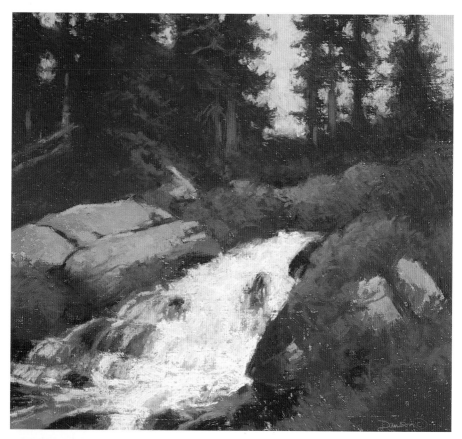

▲ **Doug Dawson**
Alpine Run Off
This artist uses his pastel almost like paint, and prepares his own grounds using pumice powder on masonite board. This gritty texture grips the pigment very firmly.

▶ **Graham Brace**
Ravens at Garn Turne Rocks
Built up in painstaking layers, colored pencil can achieve a high degree of photographic realism.

CRAHAM BRACE

Shadows

▲ **Diane Wright**

Winter Reflections

It is unusual to see such smooth areas of tone in a pencil drawing. Instead of letting the pencil marks show, which is a more usual approach, the artist has blended each area carefully to iron out any gradations of tone in the sky, shadows, and foreground. The texture of the trees brings in a touch of contrast, and their dark tone echoes that of the windows.

▼ **Martin Taylor**
Bridlepath
The cast shadows running both up and across the path play a vital role in this charcoal composition, creating a lively interplay of darks and lights. They also explain the lie of the land; notice how the tree shadows curve up and over the raised areas of the path and down into the declivities.

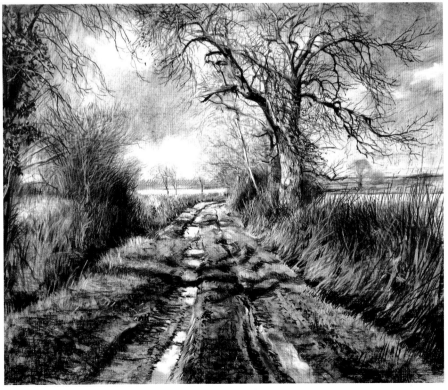

Trees and foliage

▼ **Graham Brace**
Dancing Trees
The title of this colored-pencil drawing describes the subject very well—the trees do indeed appear to be in movement. The artist has intentionally exaggerated the curves of trunks and branches, and made a lively pattern of the small twigs against the sky.

▲ **Myrtle Pizzey**
Swanchard Lane
*Working on pastel board, which holds the pastel
more firmly than paper, the artist has built up rich
surface textures that imitate those of the subject.
Short, blunt strokes describe the foliage, while the
grasses have been drawn with overlapping linear
strokes made with a sharp point.*

Fields and pastures

▼ **Doug Dawson**
High Pasture
In this lovely evocation of evening light, the overall tonality is dark, but the pastel colors are far from dull, with small strokes of red and blue enlivening the mass of foliage. The warm pink of the ground color shows through lightly overlaid blues in the distance to create subtle color mixes.

▲ **Graham Brace**
Finches at Treleddyn
The white building forms a strong focal point in the middle distance of this colored-pencil drawing, but the artist has prevented this from becoming too dominant by introducing foreground interest, which also balances the dark tones in the clouds.

Barns and farmland

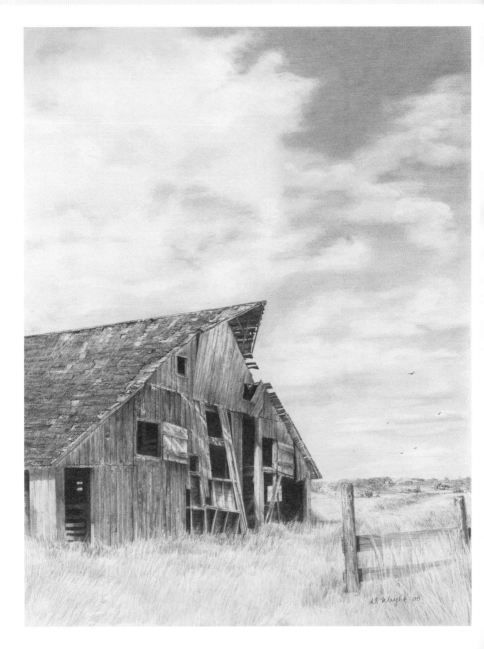

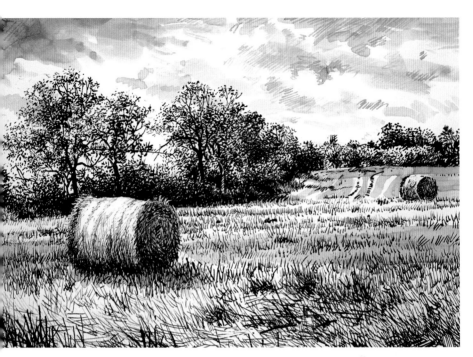

▲ Martin Taylor
Hay Bales
In this small drawing, the artist has depicted the textures of foliage and grasses very realistically by using a variety of different marks. Multidirectional pen lines, growing smaller in the distance, describe the grasses, while shorter lines, dots, and squiggles have been used for the trees. Pen and ink is not suitable for large-scale work, but is an attractive and expressive medium for small studies.

◄ Diane Wright
Mitchellville Barn
The drawing conveys a lovely sense of atmosphere, with the ruined barn and fence set against a wide expanse of sky. The textures have been built up very skillfully with different grades of pencil.

Parks and gardens

▲ Robin Borrett
Stone Summerhouse
Careful layering methods have been used to build up the colors and textures in this colored-pencil drawing, but the artist has made sure not to lose the brilliance of the hues by overworking. Small highlights on the flowers have been reserved as white paper or a paler color.

▶ Peter Woof
Topiary Levens
A medium-surface watercolor paper provides enough texture to hold the pigment, allowing the artist to build up tones and colors in several layers. This artist likes a smooth effect, rather than letting the marks of the color pencils show.

Streams and canals

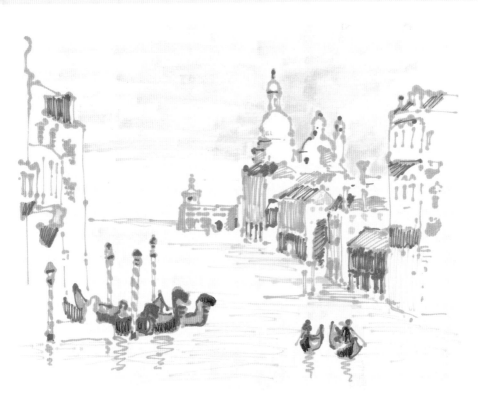

▲ **Gary Michael**
Grand Canal, Venice
Fiber-tip pens are an ideal sketching medium, and have enabled the artist to record both line and tone.

◄ **Diane Wright**
Honey Creek
A strong composition and varied, descriptive pencil marks combine to make this an exciting and satisfying depiction. Notice the care with which the artist has worked around the small highlights in the water, which create a link with the sky.

Townscapes

▼ **Joan Batty**
Baytown Morning
Soft colored pencils have been used for this
attractive drawing in which strong geometric
shapes contrast with the freer forms of the water.
The artist has used a muted version of the yellow-
violet complementary contrast to give extra sparkle
to the drawing.

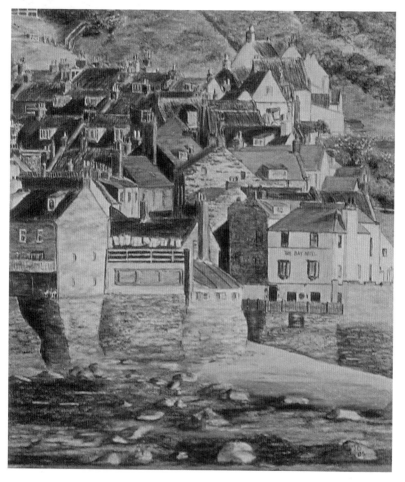

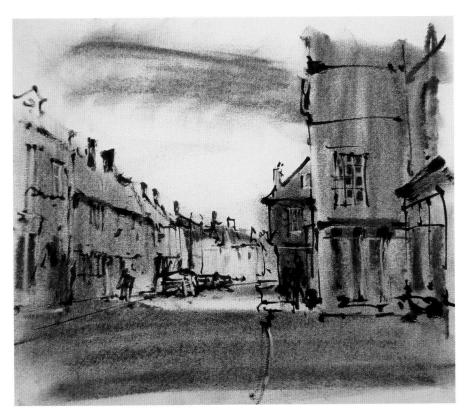

▲ **Alan Oliver**
Uppingham High Street
The combination of ink and charcoal has allowed the
artist to work rapidly. Brush pens produce thicker lines
than ordinary drawing pens, and are more convenient
for outdoor work than brush and ink.

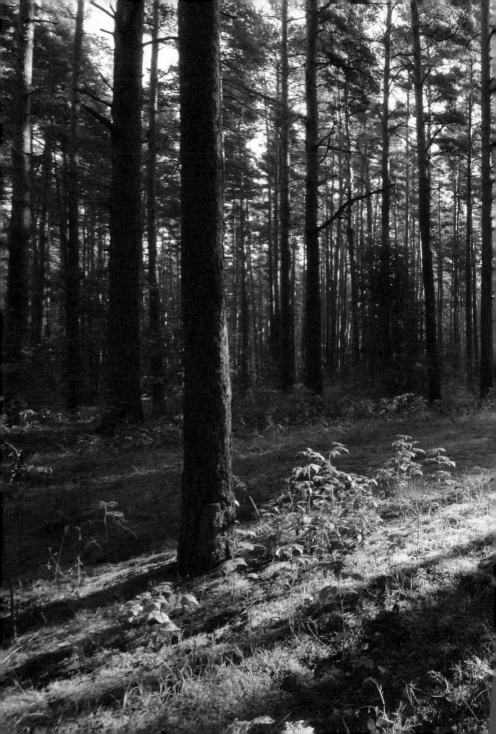

4
Photo directory

A selection of landscape photos with tips and suggestions for drawing them

Trees

▶ **Adding interest** *This is perhaps more suited to monochrome than color, but could be rendered in pastel if you bring some interest into the sky and mountains by varying the marks and overlaying colors.*

▼ **Simplifying** *This is a gift of a subject, whether you choose monochrome or color. If using graphite or charcoal, try lifting-out methods for the light areas of the sky, and simplify the network of branches into mid-toned clumps. For color work, use dark colors rather than black for the foreground.*

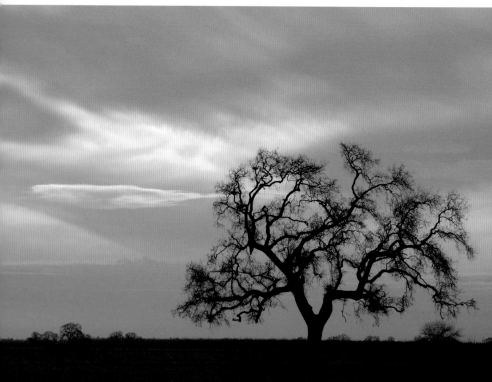

Fields

▲ *Increasing contrasts* This is a subject that would benefit from increased contrasts of tone and color. You could make the top half of the field darker or the foreground lighter, and if working in color, bring in some greens in the foreground to link with the dark trees.

▶ *Leading the eye* This is a subject that would suit any medium, whether monochrome or color. Give prominence to the diagonal band of yellow that leads in from the foreground, play down the horizontal at the top of the pumpkin field, and omit the clouds, because these could be distracting.

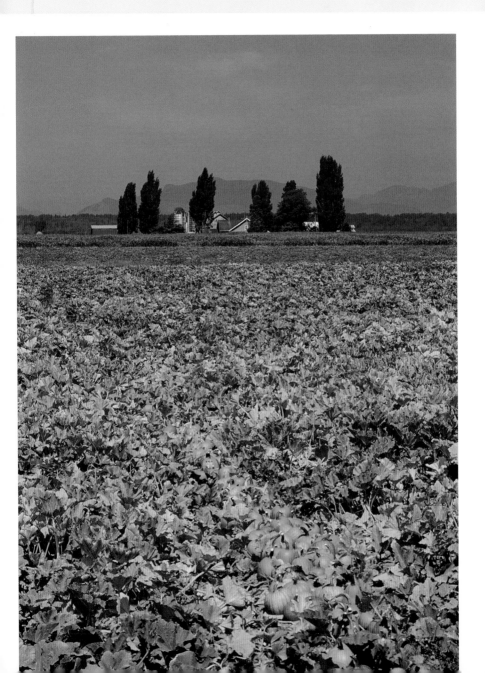

Foliage

▼ ***Omitting distracting elements*** *Good tonal contrasts and glowing colors make this an attractive subject, but it needs a little editing. The foliage coming in from top left and top right interferes with the shape of the willow and group of trees on the right bank. Both would be better omitted, and perhaps also the reeds at bottom right.*

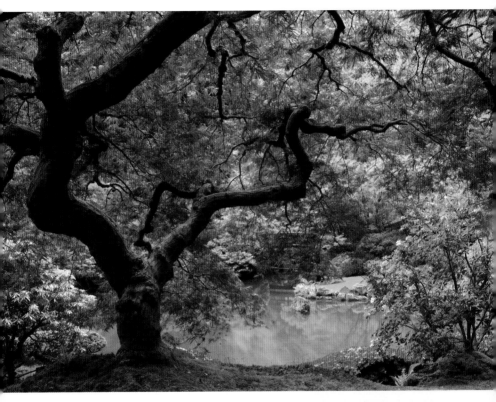

▲ **Color and tone** *This image does immediately suggest a color treatment, and would be perfect for pastel or colored pencil. However, it could be successfully rendered in graphite or charcoal by emphasizing the contrast between the solid, dark branches and the more delicate areas of middle- to light-toned foliage. The small bush on the right could be omitted.*

Rivers

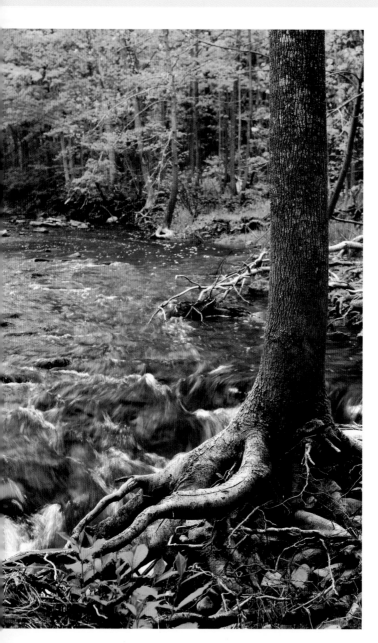

◀ *Center of interest*
The dramatic lighting from above left makes the tree roots the obvious center of interest, but the artist will need to find a way of leading the eye farther into the picture; if the main focus is in the immediate foreground, it tends to act as a block. One strategy would be to introduce patches of strong sunlight on the left bank to link all the sunlit areas.

▶ *Capturing movement The swirls of water give the subject a built-in sense of movement, but this could be exaggerated. More could be made of the water in the foreground by using strong, directional strokes and more distinct tonal contrasts, and some of the rocks, notably those at bottom left and in the center of the river, could be omitted, because they seem to interrupt the flow of the water.*

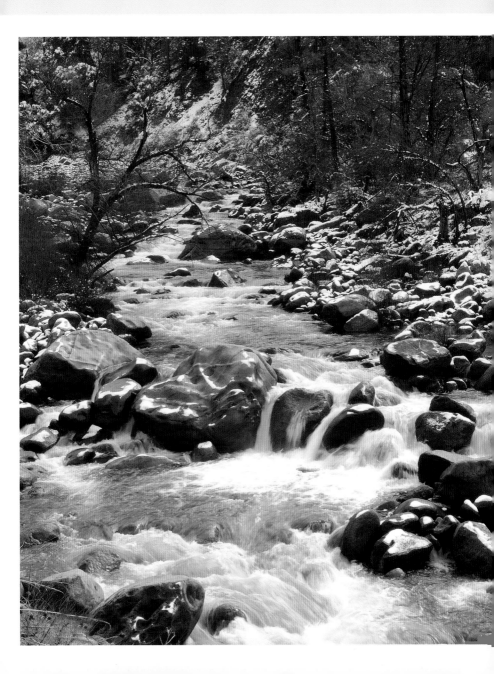

Waterfalls

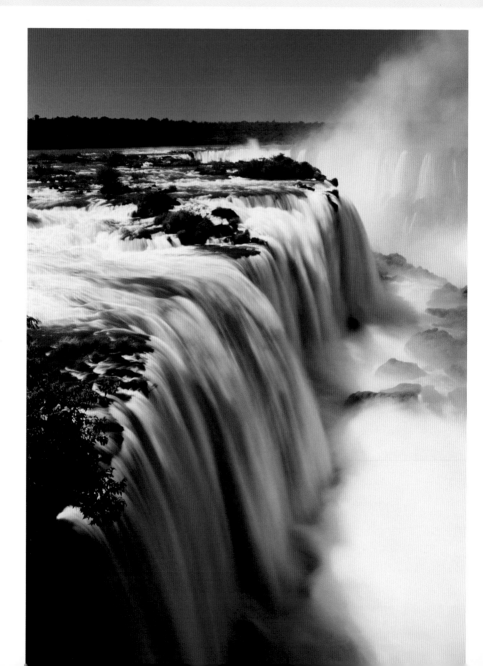

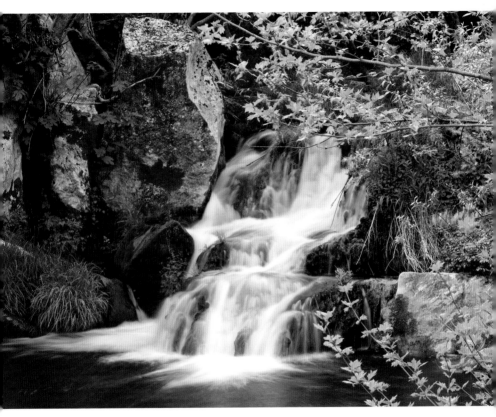

▲ **Lifting out the lights** This would work well in either monochrome or color, because both the waterfall and the rocks make strong, well-defined shapes. If using graphite or charcoal, try laying a middle tone for the waterfall and then lifting out the lightest areas by making directional strokes with a kneadable eraser.

◀ **Reflected colors** This is probably a better subject for color treatment than for graphite or charcoal, because the reflected blues in the waterfall are very exciting, and would read less well simply as variations in tone.

Rocks

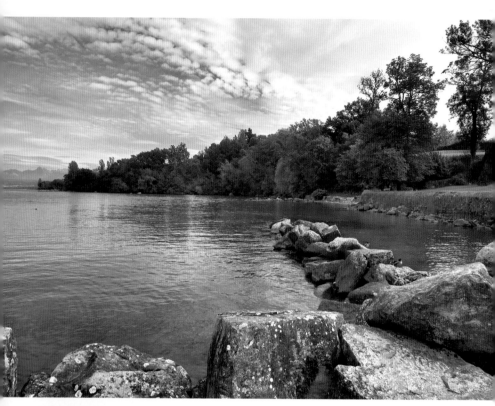

▲ **Suggesting texture** *If using a fluid medium like watercolor, resist methods could be used to suggest the texture of the rocks, but with a dry medium you will have to rely on the quality of the marks you make, using short, broken lines and squiggles. Small highlights could be lifted out with a kneadable eraser.*

▶ **Hard edges** *When drawing rocks, look for the tonal contrasts that describe the forms. These rocks are sharp rather than gently rounded, producing abrupt gradations of tones in places.*

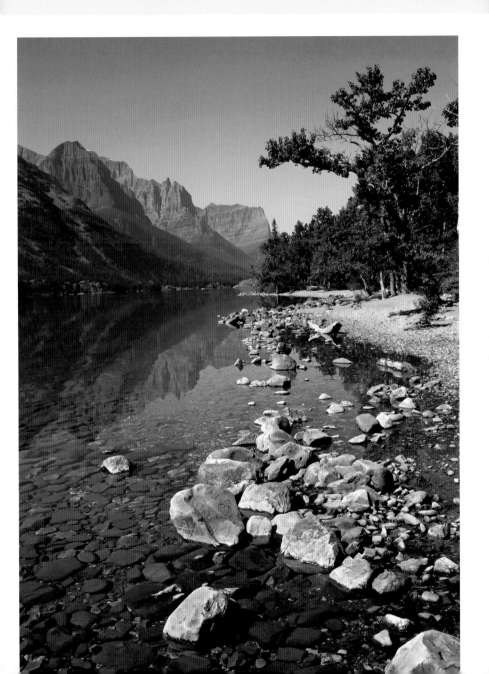

Lake views

▼ *Highlights* The building is the focal point of the image, and the sunlit wall needs to stand out strongly against the dark and middle tones. In monochrome or colored-pencil work, this is best done by reserving the wall and the highlight on the onion dome as white paper. In pastels, which are opaque, and are usually worked on colored paper, the white wall and highlight can be added last, as a finishing touch.

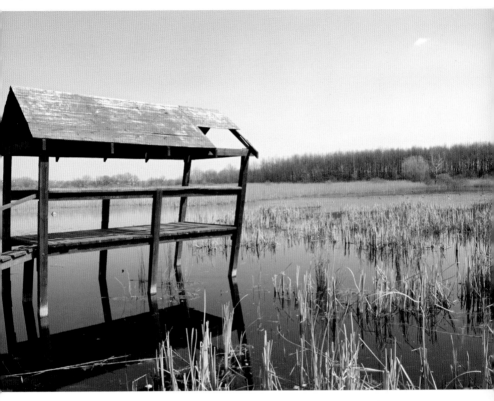

▲ **Compositional structure** *This subject has a strong composition based on verticals and opposing shallow diagonals. It could be further strengthened by making the reeds in the foreground into a more solid mass so that their tops form another diagonal following the opposite direction to that of the roof.*

Shores and cliffs

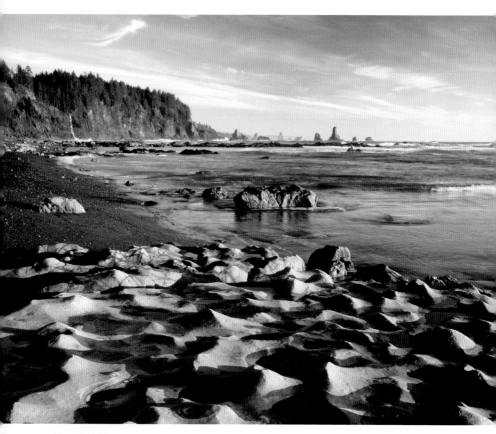

▲ **Creating drama** The extraordinary rock formations in the foreground make this a gripping subject that might be even more dramatic in monochrome than in color. The clouds claim too much attention, however, and would be best omitted.

▶ **Recession** The textures and forms of the rocks and the patterns of foam and ripples in the water invite a linear treatment, whether with pencils or pastel. Don't forget to make the background recede by using the effects of aerial perspective, making the tones lighter and the colors (if using color) bluer in the distance.

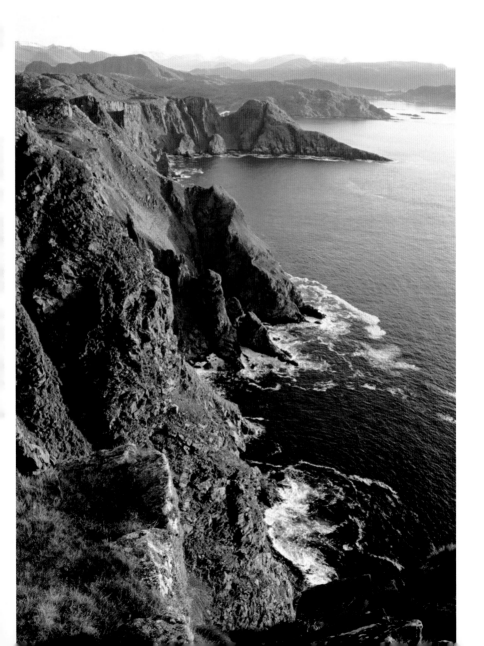

Rocky outcrops

▲ **Symmetry** *Students are always told to avoid too much symmetry, but here the central placing of the road is extremely powerful. Any medium could be used to exploit the drama of this subject.*

◄ **Creating links** *The sunlit outcrops are the focal point of the subject, but they don't relate well to the foreground. You could either change the format to a squarer one and move the stones up, or make more of the reflections so that they create a stronger link.*

Mountains

▲ **Aerial perspective** The mountains, although distant, are the clear focal point in this subject, but beware of making the tonal contrasts too sharp, or you will lose the effect of aerial perspective. Treat the foreground broadly so that the dark shapes act as a frame for the sunlit rocks and snow.

▶ **Vertical emphasis** Use your pencils or pastels to make marks that stress the verticals in the foreground and mountain, and soften the curved line at the top of the trees to make them flow into the mountain.

Snow

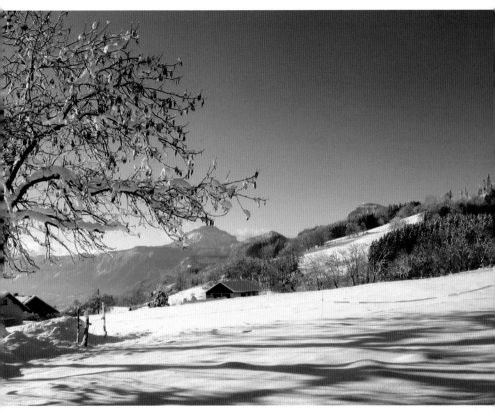

▲ **Shadows** The long cast shadows play an important role in this subject, because they explain the lie of the land as well as add interest. If working in color, emphasize the blues to make a link with the sky.

◄ **Light and dark** The dark trees set against a large area of white would make a powerful monochrome drawing, but for color work you might introduce some touches of blue and green into the foreground snow.

Skies and clouds

▲ **Making choices** Treating a sky in detail can claim too much attention, and in this case the clouds could be simplified, especially at the top of the picture, in order to draw attention to the bright stretch of water. An alternative approach would be to change the format, omitting the foreground and giving the sky a greater part of the picture area.

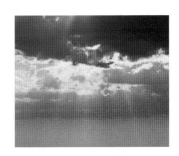

▼ *Dividing the picture plane* In this case, the sky occupies two-thirds of the picture area, and is thus the obvious "star of the show," with the foreground acting as an anchor. You might broaden the line of reflected sunlight to link the sky and land.

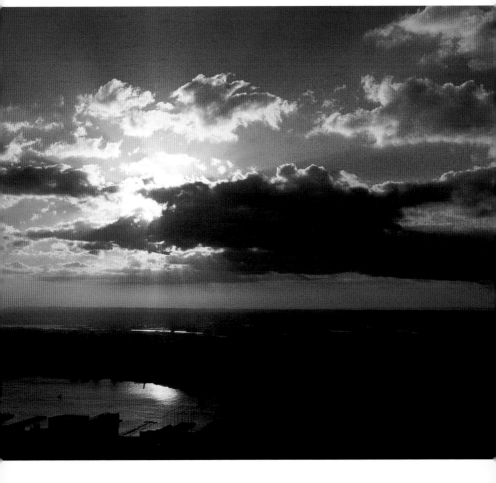

Shadows

▼ *Exploiting tonal pattern* The strong pattern created by the fence and its shadows would be best exploited in a monochrome medium, such as pencil or charcoal pencil. Blend the shadows so that you suggest the texture of the sand and create a contrast between hard and soft.

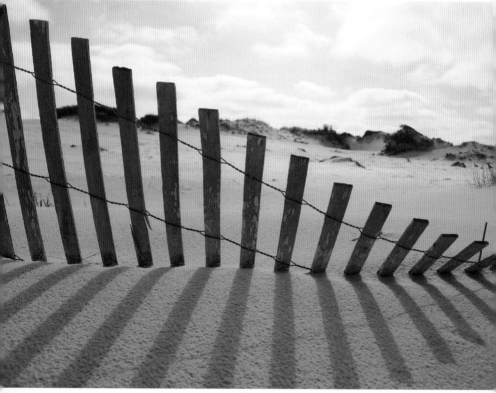

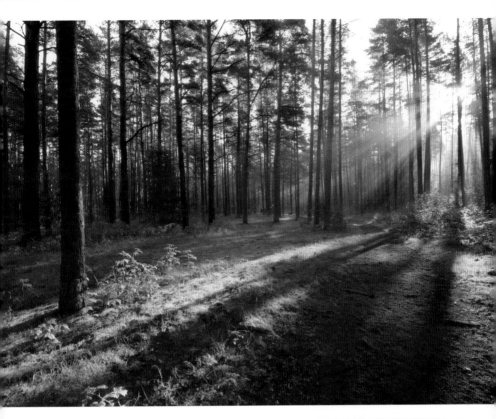

▲ **Light effects** *The low sun illuminates the bands of grass, providing a strong composition based on diagonals and verticals. This subject could be rendered in any medium, but would be especially well suited to charcoal or pastels, both of which would enable you to work broadly. You might consider bringing in some lighter tones in the right-hand foreground to balance the dominant diagonal band of light.*

Reflections

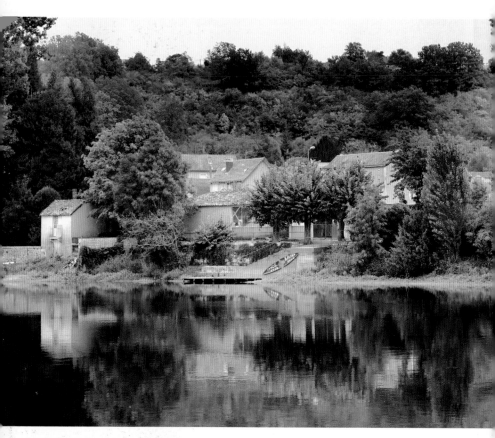

▲ **Describing water** *When drawing reflections, take care not to make them too exact or you will lose the watery feel. Use mainly downward strokes and blending methods, with some horizontals in the foreground to suggest ripples.*

▶ **Playing down** *The reflected clouds claim rather too much attention, and could be played down, either by blurring or by inventing some ripples in the foreground to scatter the reflections.*

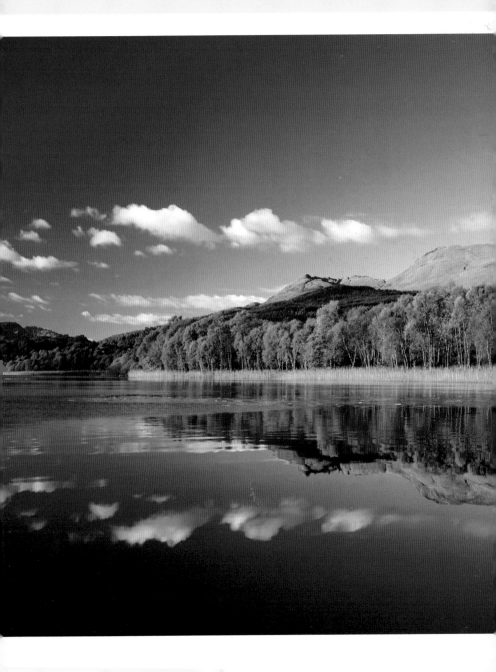

Towns and villages

▲ **Finding a reference point** When drawing a scene like this, it can be hard to know where to start, so first establish the main shape of the village and then look for a reference point, which in this case is the church with its tower and dome. Once you have sketched this in, you can relate the other buildings to it, and decide what you might simplify or leave out.

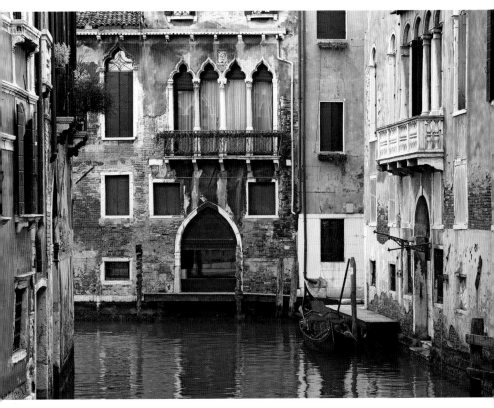

▲ **Editing the subject** *The elegant architectural detail makes this a very attractive subject, but it is a little flat, and would benefit from more light on the right-hand wall. You could also play down the detail to give more prominence to the central wall, and make more of the reflections so that they lead the eye up from the foreground.*

Cityscapes

▲ **Complementary colors** *The multicolored vertical stripes of the reflections and the violet-yellow complementary contrasts of the sky and main building make this an obvious choice for a color drawing; colored pencil would work well, because this allows for crisp detail on the roofs and walls of the building. However, the shapes and tonal contrasts are strong enough for a monochrome treatment, especially if the bottom part of the sky is lightened to make more of the roofs.*

▼ **Simple shapes** *At first sight, this might appear a daunting subject, but in fact it consists almost entirely of a series of simple geometric shapes varying in height and width. It would make a powerful monochrome drawing, and could also be tackled in pastel or colored pencil, provided some further colors are brought into the foreground and buildings. Whatever medium you choose, do omit the distracting little cloud.*

Index

Credits

Quarto would like to thank and acknowledge the following artists for taking part in the step-by-step demonstrations, and for providing finished artworks and photographs used in chapters 1 and 2.

Key: *a* above; *b* below; *l* left; *r* right; *c* center

Alan Adler 26*a*
Gordon Bennett 31*b*
Moira Clinch 74–77
Penny Cobb 64*a*, 92*b*
Rosalind Cuthbert 17*bl* & *br*
Joe Francis Dowden 110–113
Ian Fellows 16*b*
Barry Freeman 44–45, 52–53, 70–73
James Hobbs 15
Jane Hughes 82–85, 124–127
Roger Hutchins 14*a*, 78*b*, 91*b*, 101*br*, 102–105
Geoff Kersey 79*a*, 115*a*
Michael Lawes 116–117, 128–129
Nicolette Linton 130*a*
Mike Pope 22*b*
Ian Sidaway 26*bl* & *br*, 28*b*, 32*bl*, 38*a*
Stan Smith 6–7, 20*bl*
Martin Taylor 11
Valerie Warren 86*b*, 87–89, 94–95
Janet Whittle 2, 4, 35*bl*, 43*b*, 46*a*, 47–51, 55, 56–63, 64*b*, 65-67, 91*a*, 92*ar* & *br*, 93, 96–99, 101*bl*, 106–109, 114, 115*b*, 118–121
Jim Woods 69*b*, 79*b*, 80–81, 86*a*, 123, 130*b*, 131–133
Diane Wright 10, 100*al*, *cl* & *bl*

Quarto would also like to thank those artists who demonstrated additional mark-making techniques: David Cuthbert, Ruth Geldard, Brian Gorst, Jane Hughes, Roger Hutchins, Malcolm Jackson, Jane Peart, Ian Sidaway, Terry Sladden, and Martin Taylor.

Gallery
We are extremely grateful to all the artists who contributed to the gallery; their names appear in the captions that accompany their drawings.

Photo directory
Images used under license from Shutterstock, Inc.: /Mihail Jershov 156–157, 183; /Terrance Emerson 158; /Mark R. 159; /Mario Lopes 160; / Carsten Medom Madsen 162; /Jason Vandehey 163; /Elena Elisseeva 164; /Anne Kitzman 165; /Andreas G. Karelias 167; /Kavram 168; /Mike Gostomski 169; /Kurt Tutschek 170; /Péter Gudella 171; /Beata Jancsik 174; /SNEHIT 178; /Thierry Maffeis 179; /Lane Lambert 180; /LouLouPhotos 182; /Christopher Lofty 184; /Naturablichter 186; /Kazakov 187.

All other illustrations and photographs are the copyright of Quarto Publishing plc. While every effort has been made to credit contributors, Quarto would like to apologize should there have been any omissions or errors—and would be pleased to make the appropriate correction for future editions of the book.